# Draw *like* *the*Masters

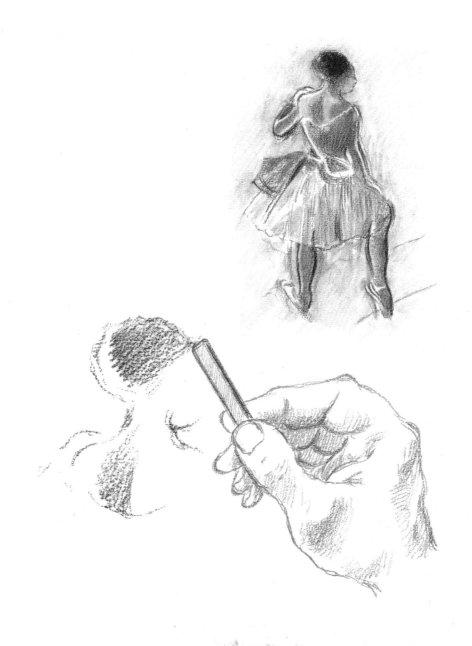

# Draw *like* *the* Masters

## BE INSPIRED BY GREAT ARTISTS OF THE PAST

**Barrington Barber**

ARCTURUS

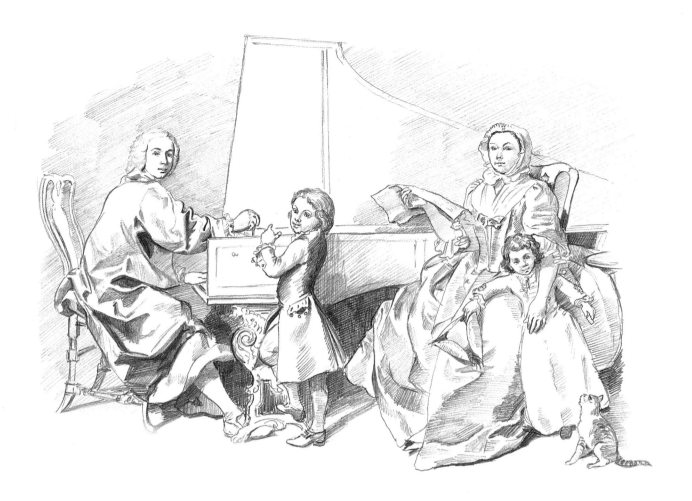

ARCTURUS

This edition published in 2014 by Arcturus Publishing Limited
26/27 Bickels Yard, 151–153 Bermondsey Street,
London SE1 3HA

Book design by Alex Ingr at www.typeandimage.com, London N1

ISBN: 978-1-78404-044-4
AD004294NT

Printed in China

# Contents

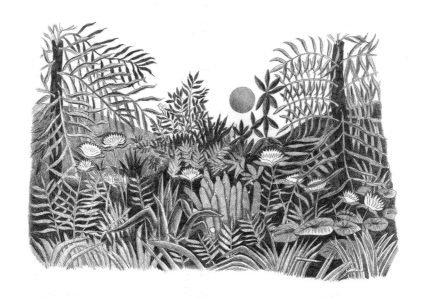

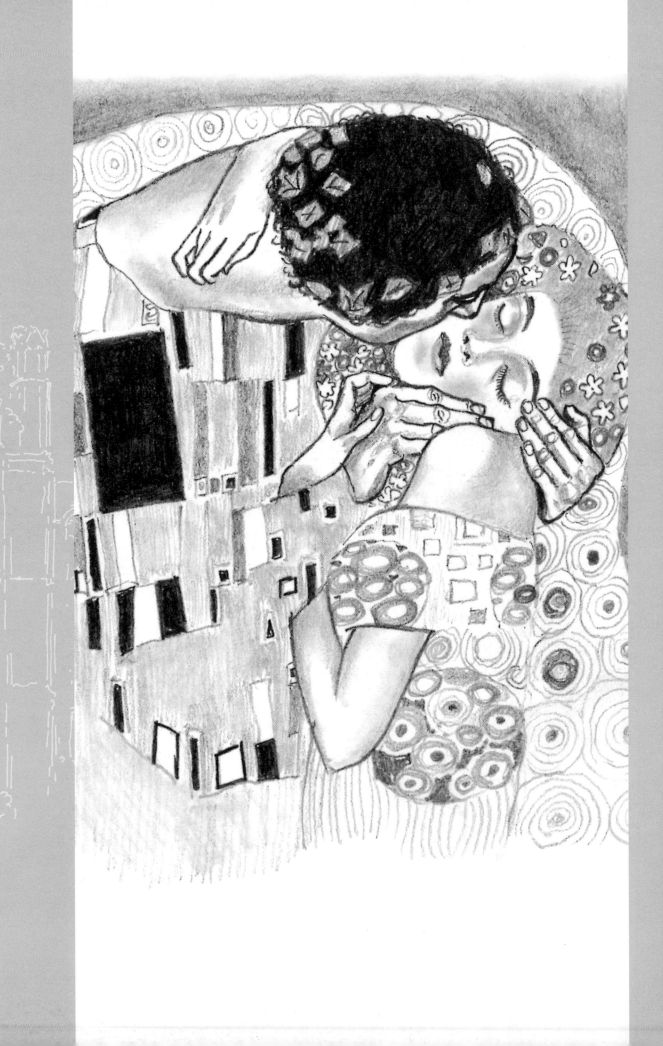

# Introduction

Draw Like the Masters is about the age-old method of copying from a master drawing in order to learn how to draw well. In previous ages, in a studio run by a master artist, there would have been regular periods when the assistants, or apprentices, would carefully copy drawings done by the master or by his best assistant. These would have to be as exact as possible, in order to help the young student to learn the art of drawing. This was unlike the later idea that all artists have to be original and, in fact, originality was not considered of any import. The student artist was expected to try to be as similar to his master in style and quality as possible. When he was accomplished in the art of copying, he would be entrusted with drawing up certain parts of the works produced by the master and his studio. In this way, he would gradually become a major worker on the pictures produced by that studio and, when he had mastered all the techniques, would be allowed to initiate works of his own. From there he would perhaps start his own studio, and in time employ other young hopefuls, who would go through a similar process. By this system, in quite a short time, many competent artists were produced who could handle a wide range of artworks. Even the studio drawings, which were kept for reference purposes, would all be drawn in common sketch books that held works by several of the artists working there. It was very much a corporate effort. After a while, the system would be rejuvenated by a new artist of sufficient stature to add new ideas to the regular canon of art examples. But the normal working procedure was always based on the student learning directly from the master, by copying his drawings and methods.

When you embark on this way of learning to draw, you will find how difficult it is to copy accurately. But gradually, you will begin to see and understand the subtleties of the drawing methods. Once you have discovered how the original drawing was done in some detail, you won't forget easily how to do it yourself. And once this degree of expertise is achieved, your drawing, although derived from a particular master source, begins to take on its own character, which is when your own style starts to make itself apparent.

So copying, as a tried and tested method, is really quite an efficient way to improve your artistic endeavours, and as long as you stick to the best master works that you can find, you should have no problem in improving your drawing skills.

# Line drawing

Drawing at its most basic may be described as the making of marks on a surface and, more particularly, as the arrangement of lines drawn in pencil, ink, charcoal or chalk.

This section features copies of works by master draughtsmen, which rely for their effectiveness on nothing but the quality of their linework to describe the subject. I cannot show the entire chronological development of line drawing, prehistoric examples of which are to be found on the walls of caves in France and the Sahara; so I have selected attributed works by some of the more major artists, which I think demonstrate a good variety of approaches to the task, with enlarged details that highlight the techniques being used and the effects these can create.

Nor are the following drawings mere outlines – they also show us how a master can convey the feeling of weight and substance by his handling of the medium. The slightest manipulation of a line can be made by him to suggest a three-dimensional shape in motion or at rest. Any aspiring artist does well to emulate the ability of a master to define shapes by simple means. Good drawing does not have to involve complexity.

It becomes clear from these examples that understanding how to draw a line in various and subtle ways enormously enhances the quality of your work. The strength of the line, its sensitivity, its ability to change in intensity, and other variations of method, all help the artist to suggest a range of effects with very little complexity.

## Michelangelo Buonarroti (1475–1564)

Michelangelo is arguably the most influential figure in the history of art; a good example to start with. Study his drawings and then look at the work of his contemporaries and the artists who followed him and you will see how great was his influence. The copy shown here incorporates the original techniques he introduced. In the pen and ink drawing the style is very free and the shapes very basic, suggesting figures in motion; Michelangelo's deep knowledge of anatomy enabled him to produce an almost tactile effect in his life drawing. He shows clearly that there are no real hollows in the human form, merely dips between the mounds of muscles. This is worth noting by any student drawing from life and will give more conviction to your drawing.

## Guercino (1591–1666)

Rarely have I seen such brilliant line drawings in ink of the human figure as those of the painter Guercino. In this example the line is extremely economical and looks as though it has been drawn from life very rapidly. The flowing lines seem to produce the effect of a solid body in space, but they also have a marvellous lyrical quality of their own. Try drawing like this, quickly, without worrying about anything except the most significant details, but getting the feel of the subject in as few lines as possible. You will have to draw something directly from life in order to get an understanding of how this technique works.

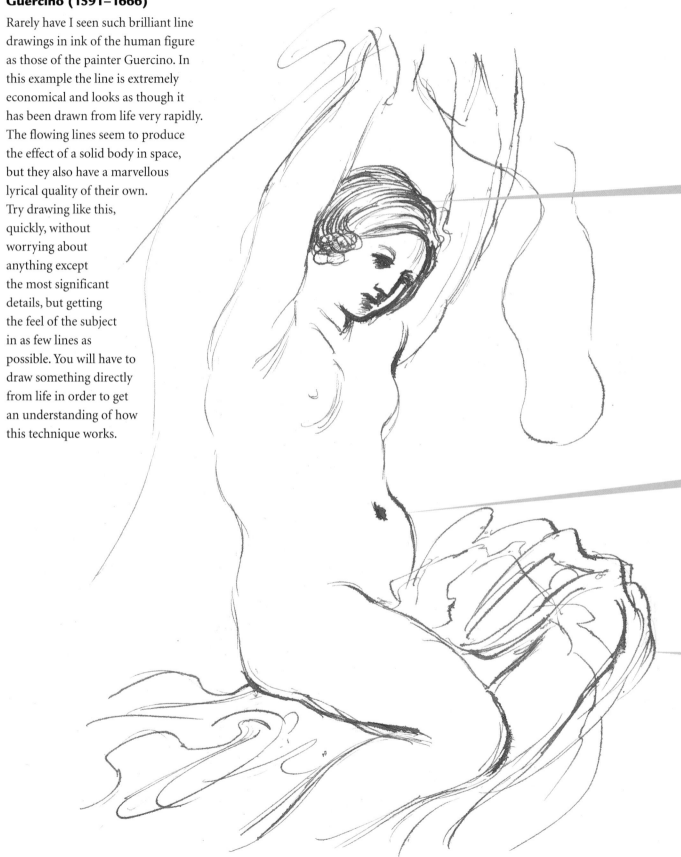

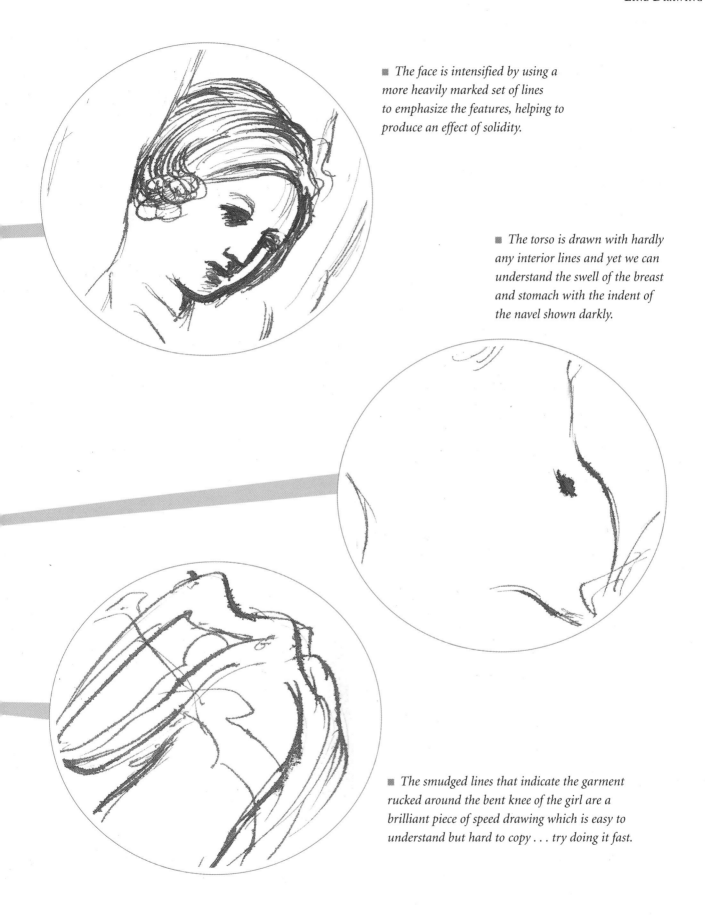

■ *The face is intensified by using a more heavily marked set of lines to emphasize the features, helping to produce an effect of solidity.*

■ *The torso is drawn with hardly any interior lines and yet we can understand the swell of the breast and stomach with the indent of the navel shown darkly.*

■ *The smudged lines that indicate the garment rucked around the bent knee of the girl are a brilliant piece of speed drawing which is easy to understand but hard to copy . . . try doing it fast.*

### Joseph Mallord William Turner (1775–1851)

Turner started his career as a topographical painter and draughtsman and made his living producing precise and recognizable drawings of places of interest. He learnt to draw everything in the landscape, including all the information that gives the onlooker back the memory of the place he has seen. This ability stayed with him, even after he began to paint looser and more imaginative and elemental landscapes. Although the detail is not so evident in these canvases, which the Impressionists considered the source of their investigations into the breaking up of the surface of the picture, the underlying knowledge of place and appearance remains and contributes to their great power. The outline drawing of this abbey is an early piece, and amply illustrates the topographic exactitude for which the artist was famous in his early years.

■ *The tottering pinnacles of the ruined abbey are so lightly drawn that they only just work – but work they do. This tremendous economy of line is typical of a topographical expert like Turner.*

■ *The outline of the arch and the other parts of this medieval ruin are brilliantly seen in perspective, and with enough suggestion of detail to give the effect of decaying masonry. The accuracy of the sparsely outlined drawing is not so easy to get right, and a good way to practise is by tracing in this way over a photograph.*

■ *These loosely drawn lines are not quite so casual as they look. They are almost like a tracing of an image with just enough precision, which conjures up the feel of the building and foliage so well.*

**Eugène Delacroix (1798–1863)**

The great French Romantic painter Delacroix could draw brilliantly. He believed that his work should show the essential characteristics of the subject matter he was portraying. This meant that the elemental power and vigour of the scene, people or objects should be transmitted to the viewer in the most immediate way possible. His vigorous, lively drawings are more concerned with capturing life than including minuscule details for the sake of it. He would only include as much detail as was necessary to convince the viewer of the verisimilitude of his subject. As you can see from these examples, his loose, powerful lines pulsate with life.

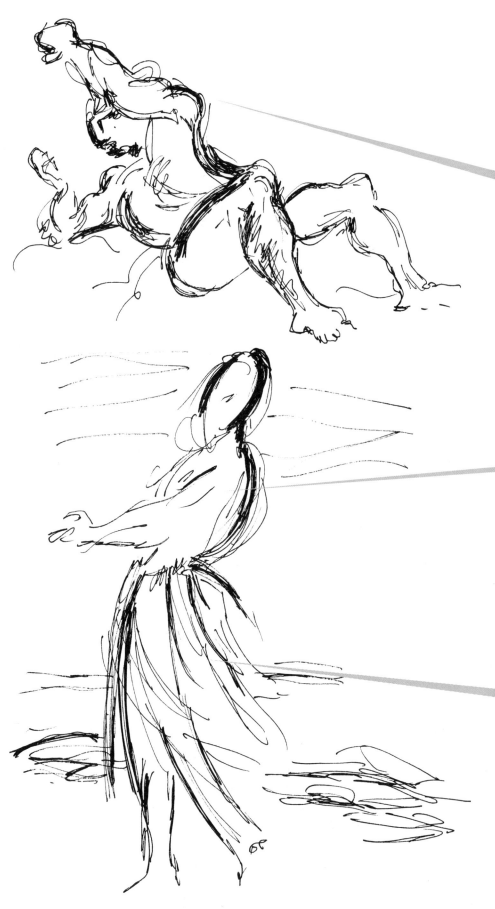

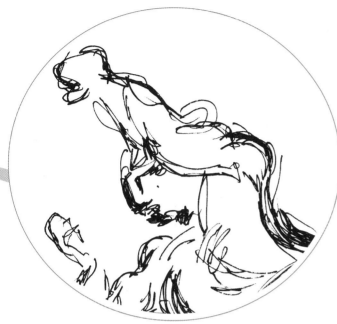

■ In the raised arm of this reclining figure there is vigour and a sense of life and movement. The loosely drawn lines hardly show any of the anatomy of the limb, but nevertheless give us a feeling of strength and solidity.

■ The blank face and hardly drawn arm and torso are convincing enough to tell us that this female figure is turning towards us as she swings her arm forward. The strongly emphasized line around the head and the back give strength as well as movement to the pose.

■ The carelessly drawn legs and skirt help to convince us that we are seeing a human figure dancing or gesturing. It is so unformed that one feels that anyone could do it. Try it yourself.

# Tone

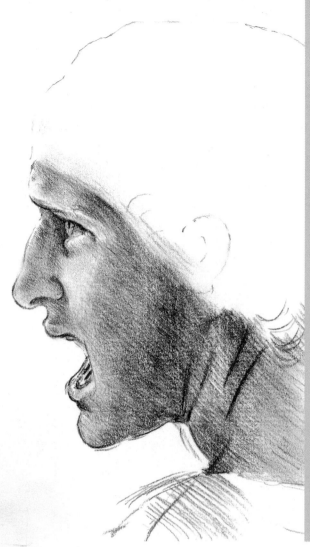

Creating tone, with areas of shade softly merging into one another, is the next step after line to making a drawing appear more convincing. The use of tone probably arose some time after the use of line; certainly the frescoes at Pompeii had tonal areas to give substance and form to the figures they portray.

Tone allows us new ways to express form. The following examples help to convince the viewer of the weight of objects, and of the depth of field in a picture. Some examples show how repetition of fine lines can render the same effect as tonal areas, and others dispense with line altogether.

Careful gradation of tone on an object persuades us that it is occupying a volume in space; the more fine the gradation, the more readily the eye is convinced. We are so used to looking at photographs that tonal drawing is equally acceptable as evidence of the reality of the subject.

If the tonality is convincing enough, we think it must exist somehow, somewhere, even though our reason tells us otherwise.

Nowadays it is not too difficult to reproduce people, objects, architecture and landscapes accurately. But at the start of the Renaissance period it was still a challenge for most artists to encourage the viewer to believe in the depth of field in a picture or the reality of a subject. However, by the mid-1500s, when the Baroque era was under way, artists had learned how to handle graded tonal values as well as anyone did nearly three hundred years later on, with the invention of photography.

The artists shown here are great exponents of tonality, but you can also learn a lot from studying photographs taken in natural light – not shot with a flash, which tends to flatten the tones.

## Vittorre Carpaccio (1472–1526)

Tone, or the relative values between the light falling on an object and the shadow in its varying depths, on and around the same object, help to convince the viewer that it is a three-dimensional thing in space. The earliest attempts at this were effective, but not so effective or dramatic as in later times.

Here the dominant area of tone is that of the paper the drawing has been worked on. With great economy but precise method, Carpaccio uses white and black chalk to give the effect of light and shade, which is convincing enough to produce a three-dimensional-looking head and shoulders, in space, lit by light from the upper left of the head.

The mid-tone of the paper has been used to great effect in this copy of Carpaccio's drawing of a Venetian merchant. Small marks of white chalk pick out the parts of garments, face and hair that catch the light. No attempt has been made to join up these marks. The dark chalk has been used similarly: as little as the artist felt he could get away with. The medium tone of the paper becomes the solid body that registers the bright lights falling on the figure. The darkest tones give the weight and the outline of the head, ensuring that it doesn't just disappear in a host of small marks.

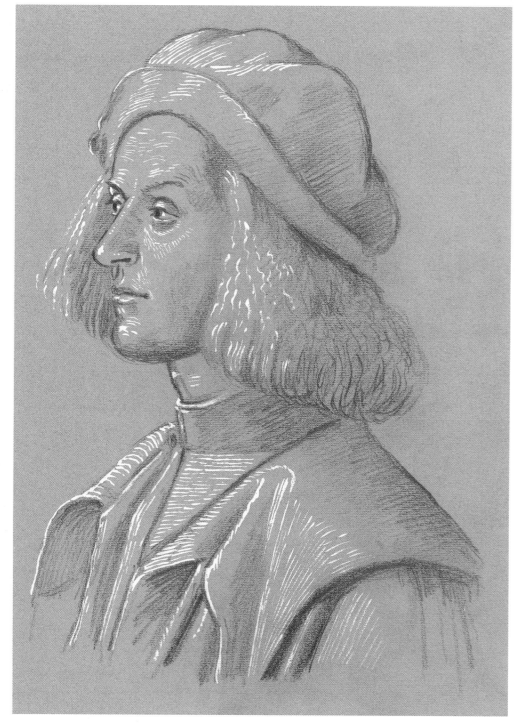

### Canaletto (1697–1768)

It is easy to become confused with the details of texture in a scene such as this, of the Grand Canal in Venice. It exemplifies one of landscape's golden rules: always put the main shapes of buildings in first. The repetition of architectural details must be kept as uniform as possible, otherwise the buildings will look as though they are collapsing. Never try to draw every detail: pick out the most definite and most characteristic, such as the arches of the

nearer windows and doors, and the shapes of the gondolas in the foreground. The reflections of the buildings in the water are suggested, with the darkest shadows depicted by horizontal lines under the buildings. Multiple cross-hatching denotes the darker side of the canal. On the lit side, white space has been left and the sky above lightly shaded to enhance the definition and provide greater contrast.

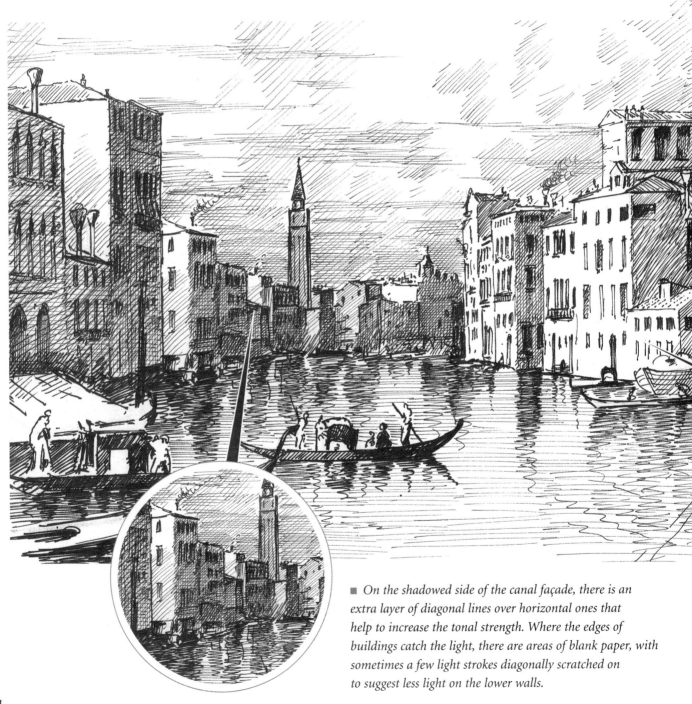

■ *On the shadowed side of the canal façade, there is an extra layer of diagonal lines over horizontal ones that help to increase the tonal strength. Where the edges of buildings catch the light, there are areas of blank paper, with sometimes a few light strokes diagonally scratched on to suggest less light on the lower walls.*

■ *A rather different way of showing tone, by using a multiplicity of drawn lines in ink to show variety in light and shade. Canaletto's view of the Venetian Grand Canal shows a corner of a building which has one surface fully lit by leaving out any tonal marks, except in the windows and decorative cornices. The side that is turned away from the light has been covered with diagonal strokes of about the same weight, leaving only small areas of white, again to indicate the indentation of the windows and balconies.*

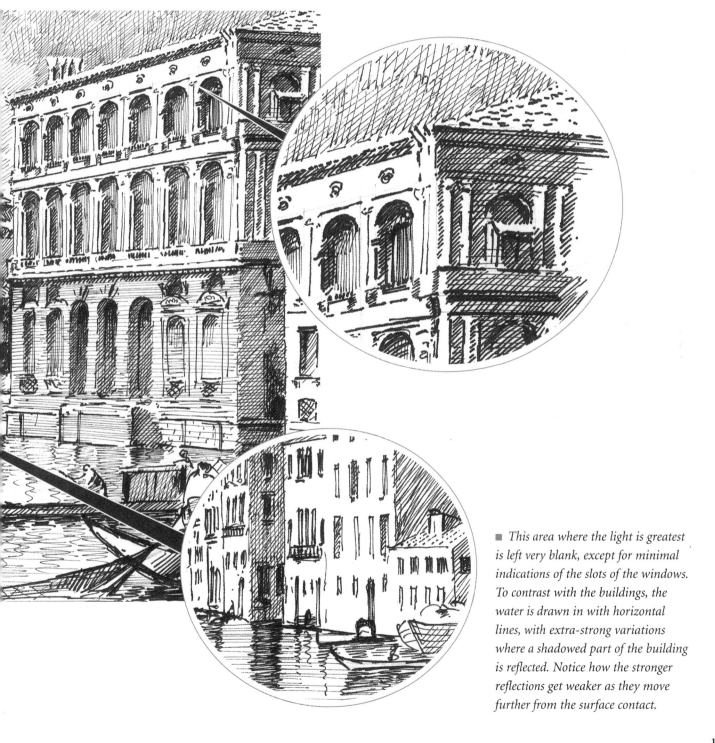

■ *This area where the light is greatest is left very blank, except for minimal indications of the slots of the windows. To contrast with the buildings, the water is drawn in with horizontal lines, with extra-strong variations where a shadowed part of the building is reflected. Notice how the stronger reflections get weaker as they move further from the surface contact.*

### Antoine Watteau (1684–1721)

In Watteau's picture of a goddess, the dark outline emphasizes the figure and limbs, as do the patches of bright light on the upper facing surfaces. As we have seen on a previous page, the toned paper makes white so effective and reduces the area you have to cover in chalk.

■ *This is a classically trained artist drawing in a similar way to Carpaccio (page 17) using a toned paper and just putting in the darkest and lightest tones in chalk. This enables him to reduce the actual amount of drawing to the minimum, but of course, he has to be that much more accurate in what he does put down. The difference between the earlier artist and Watteau is that the latter has the confidence to make his marks looser and softer-edged.*

### Leonardo da Vinci (1459–1519)

When we look at a Leonardo drawing we appreciate the immense talent of an artist who could not only see more clearly than most of us, but also had the technical ability to express his vision on paper. We see the ease of the strokes of silverpoint or chalk outlining the various parts of the design, some sharply defined and others soft, and in multiple marks that give a three-dimensional impression of the surface.

Leonardo regulates light and shade by means of his famous sfumato method (Italian for 'evaporated'), a technique by which an effect of depth and volume is achieved by the use of misty tones. The careful grading of the smudgy marks used in this drawing produces the convincing appearance of three dimensions.

The dimensional effect is also achieved with closely drawn lines that appear as a surface, and are so smoothly, evenly drawn that our eyes are persuaded. There is elegance in the way he puts in enough tone but never too much. To arrive at this level of expertise requires practice. However it is worth persevering with such techniques since they enable you to produce the effects you want with greater ease.

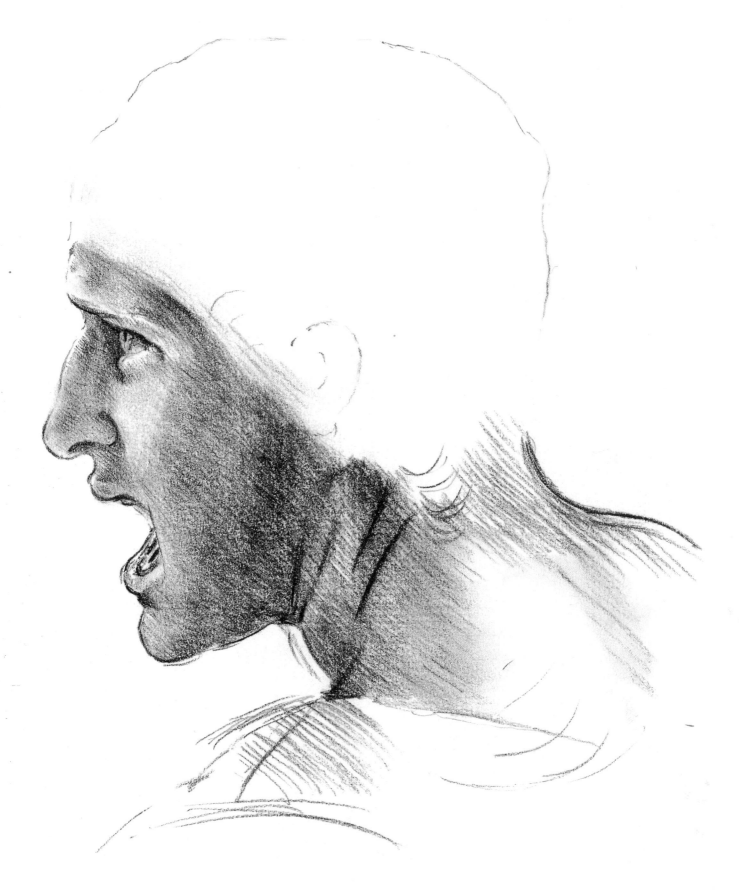

### Jean-Auguste-Dominique Ingres (1780–1867)

Ingres was an artist noted for his draughtsmanship. His drawings are perfect even when unfinished, having a precision about them which is unusual. He is thought to have made extensive use of the camera lucida – a device whereby a prism was used to transfer the image of a scene onto paper. This is probably correct, but nevertheless the final result is exceptional by any standards.

The incisive elegance of his line and the beautifully modulated tonal shading produce drawings that are as convincing as photographs. Unlike Watteau's, his figures never appear to be moving, but are held still and poised in an endless moment.

The student who would like to emulate this type of drawing could very well draw from photographs to start with, and when this practice has begun to produce a consistently convincing effect, then try using a live model. The model would have to be prepared to sit for a lengthy period, however, because this type of drawing can't be hurried. The elegance of Ingres was achieved by slow, careful drawing of outlines and shapes and subtle shading.

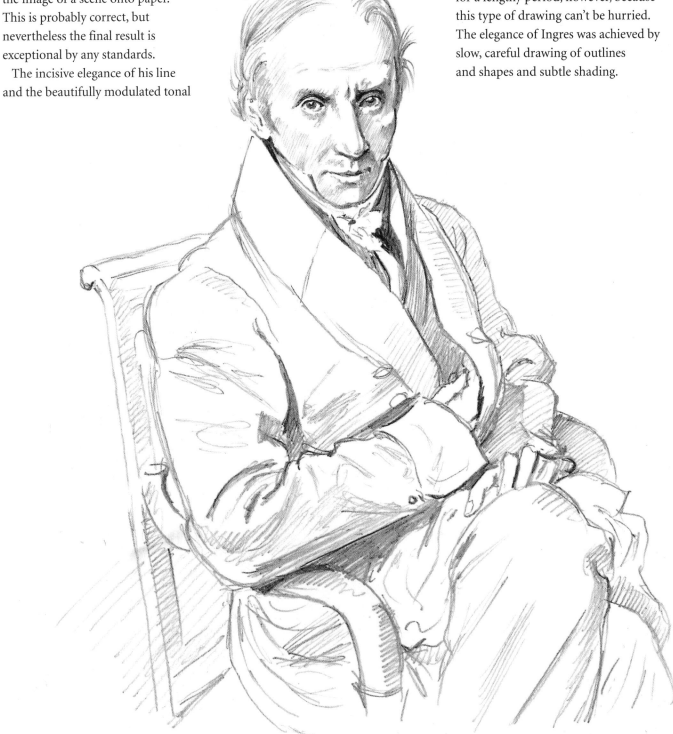

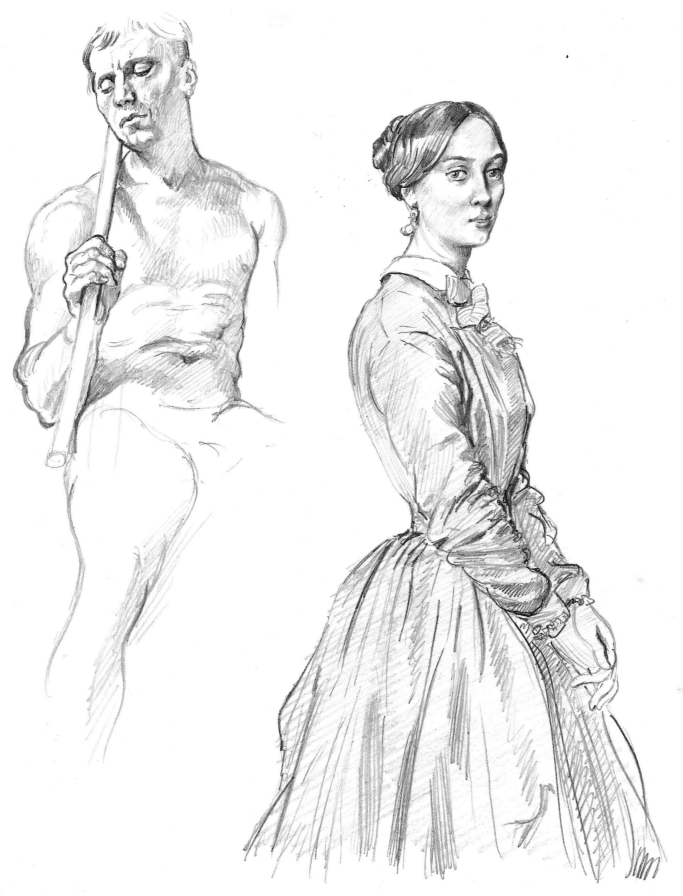

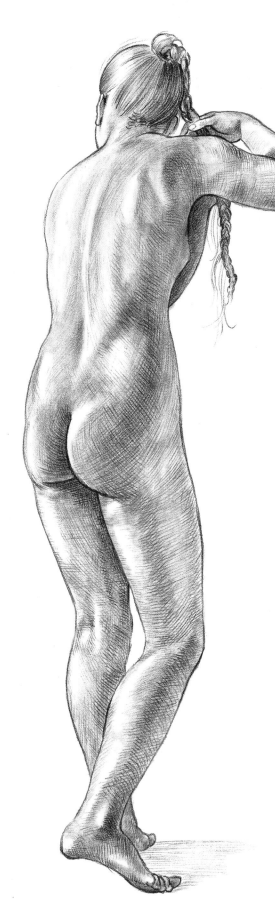

This meticulous pencil drawing by
the German **Julius Schnorr von
Carolsfeld (1794–1872)** is one of
the most perfect drawings in this
style I've ever seen. The result is quite
stupendous, even though this is just
a copy and probably doesn't have the
precision of the original. Every line
is visible. The tonal shading which
follows the contours of the limbs is
exquisitely observed. This is not at all
easy to do and getting the repeated
marks to line up correctly requires
great discipline. It is worth practising
this kind of drawing because it will
increase your skill at manipulating
the pencil and really test your ability
to concentrate.

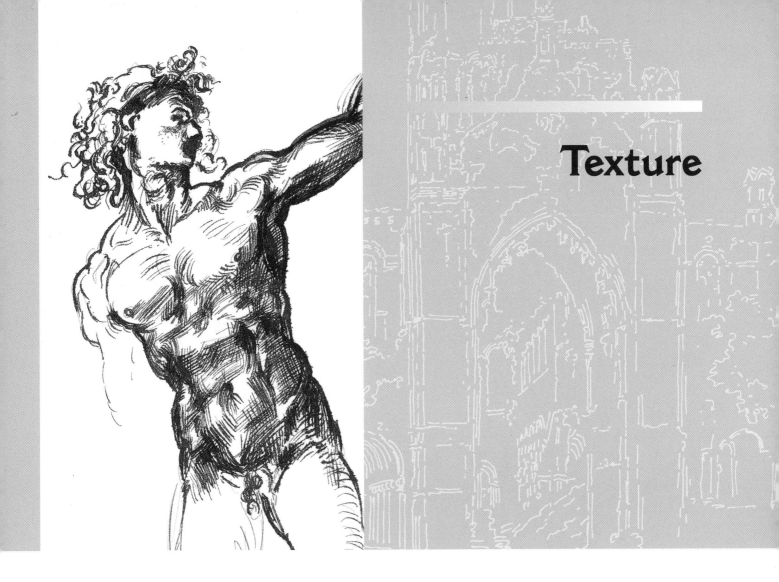

# Texture

The representation of texture has an interesting function in a drawing because it is capable of doing two things at once. It partly convinces the viewer of the dimensional quality of a scene, and also imparts a general sense of touch to the picture. Although, of course, there is no actual touching involved, our intellectual stimulus is related to our experience of texture in real life. If, for example, a glass jar is drawn reproducing the reflections usually seen in real glass, the eye 'reads' that the material of the jar is glass and persuades our other senses that this is so. Not only that, the overall artistic handling of the picture can give us a sense of the density and materiality of the subject.

Every artist in this section has succeeded in reproducing scenes and people with considerable skill in terms of textural quality; from surfaces that make you believe you can almost feel them, to scenes in which you can sense the space and solidity of features. Sometimes, the marks are drawn with a strong, almost bristly quality to them, so that as one's gaze wanders across the surface, scanning the scene, one gets an impression of tangible materiality. At other times, the smoothness and subtlety of the artist's marks create a homogeneity, which calms the visual response. The interpretation of texture is important in helping to connect our senses more closely to the subject matter of the composition.

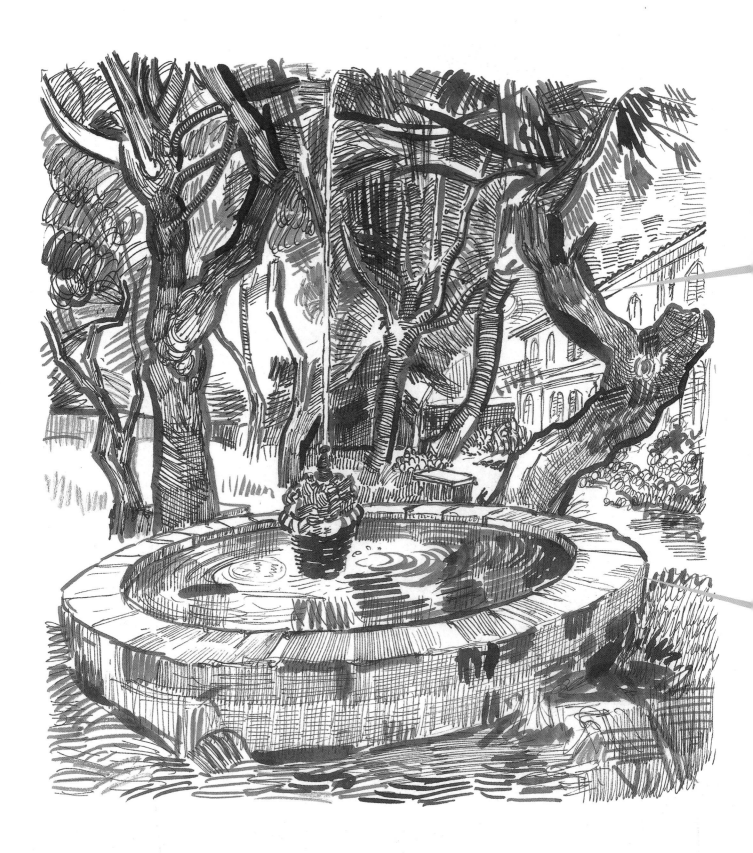

**Vincent van Gogh (1853–1890)**

In Van Gogh's *Fountain in the Garden of St Paul's*, there is graphic emphasis on the lines of the various trees and stones and the handling of textural effects to create tone and weight. The mixture of large slashing marks and fine hatched lines builds a convincing and vigorous picture that packs quite a punch.

■ *Look at the fine detail of the lines criss-crossing, to suggest the rough surface of the stone surround of the fountain, limited by the thick, solid lines of the upper edge and the ripples in the water.*

In this loosely drawn copy of a composition by **John Constable (1776–1837)**, the areas of trees and buildings have been executed very simply. However, great care has been taken to place each shape correctly on the paper. The shapes of the trees have been drawn with loosely textured lines. The areas of deepest shadow show clearly, with the heaviest strokes reserved for them.

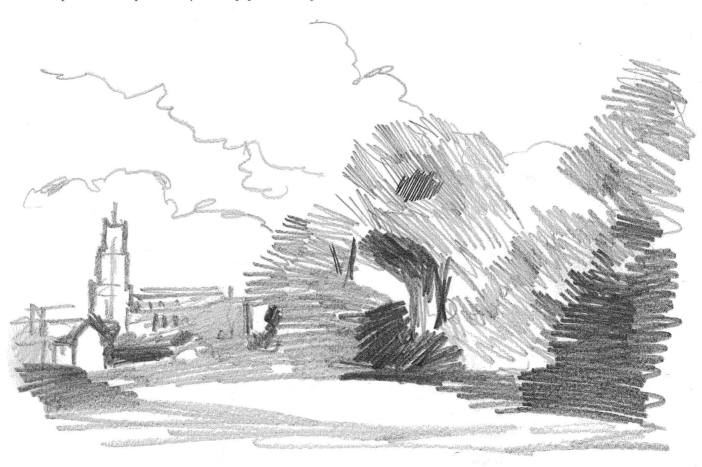

When producing landscape drawings it is very easy to be daunted by the profusion of leaves and trees. Do not attempt to draw every leaf. Draw leaves in large clumps, showing how the brightly lit leaves stand out against ones in the shadow. Each group of leaves will have a characteristic shape which will be repeated over the whole of the tree. Obviously these will vary somewhat, but essentially they will have a similar construction. You can do no better than to look at Constable landscapes and notice how well he suggests large areas of leaves with a sort of abstract scribble. He also suggests the type of leaf by showing them drooping or splaying out, but he doesn't try to draw each one.

The only part of a landscape where you need to draw the leaves in detail is in the nearest foreground. This persuades the eye into believing that the less detailed areas are further back.

In this drawing the great Renaissance artist **Raphael Sanzio (1483–1520)** used a very particular technique of the time, which was probably influenced by Michelangelo. The use of ink in clearly defined lines and lightly textured cross-hatching, gives a very precise result in which there is no doubt about the shape and bulk of the figure. It is a good, albeit rather difficult, method for a beginner that is worth practising and persisting with.

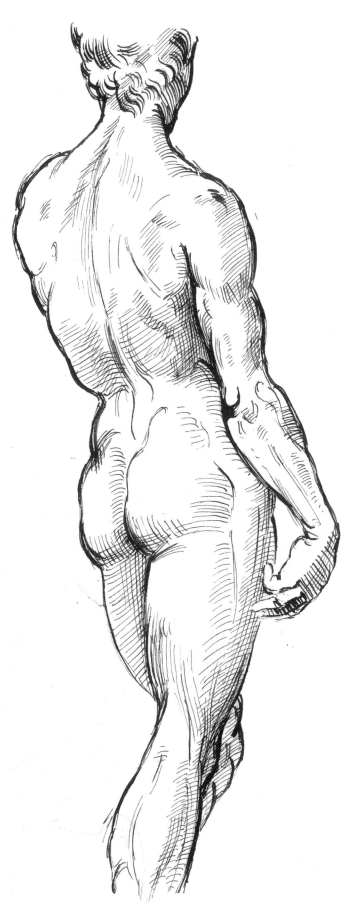

This next copy, of a **Michelangelo** drawing, is much more heavily worked over than the Sanzio still-life, with hefty cross-hatching capturing the muscularity of the figure. The texture is rich and gives a very good impression of a powerful, youthful figure in its prime. The left arm and the legs are unfinished but even so the drawing has great impact.

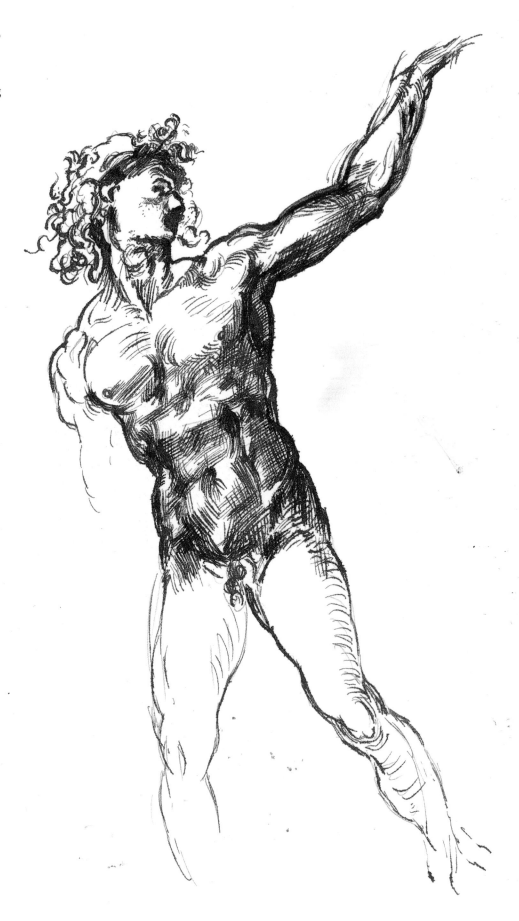

**Henry Fuseli (1741–1825)** drew this self-portrait when he was in his thirties. It shows the anxieties and self-doubt of someone mature enough to be aware of his own shortcomings. B and 2B soft pencils were used for this copy to capture the dark and light shadows as well as the sharply defined lines depicting the eyes, nose and mouth.

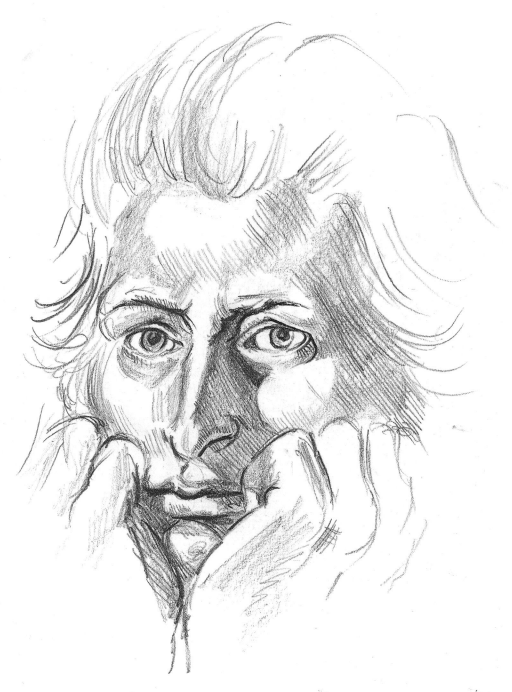

■ *Note the textural handling of the face with its evenly drawn tonal lines, and vigorous and free outlines.*

33

In his masterly original of this ink line drawing, **Jacopo Tintoretto (1518–1594)** was careful to get the whole outline of the figure. The curvy interior lines suggest the muscularity of the form. There is not too much detail but just enough to convince the eye of the powerful body; every muscle here appears to ripple under the skin. The barest of shading suggests the form.

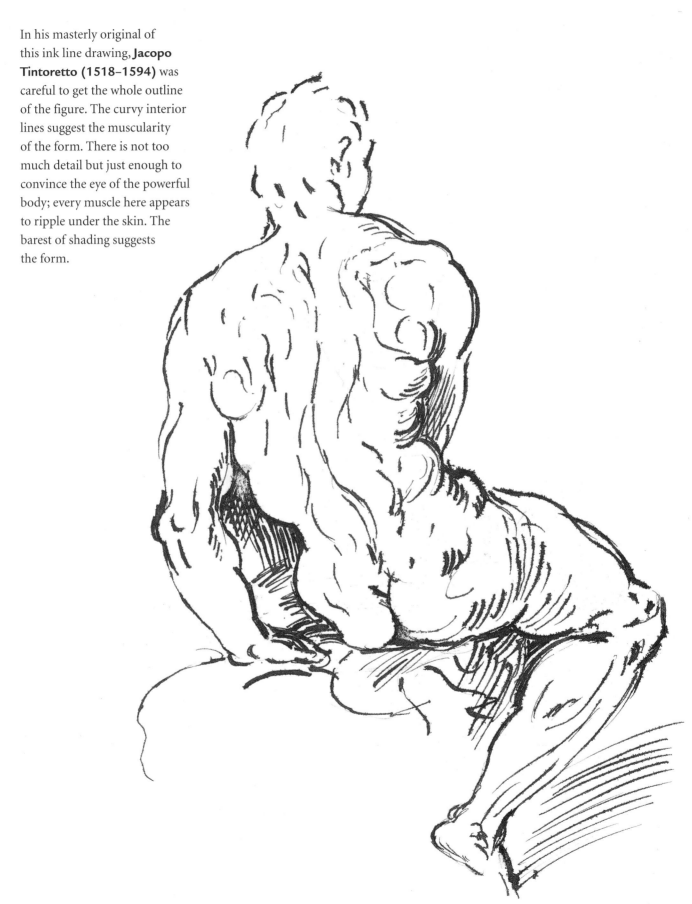

**Michelangelo**'s drawing is much smoother in texture because he has put in the halftones and not only the bare lines as in Tintoretto's. This texture gives a more tactile quality to the figure.

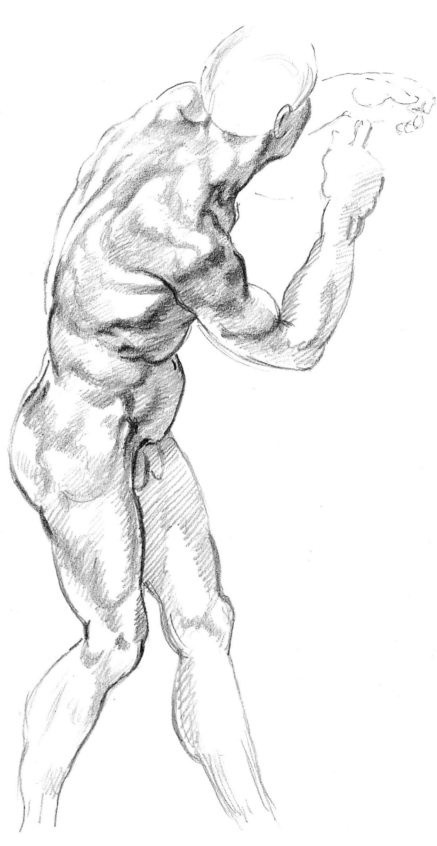

# Form

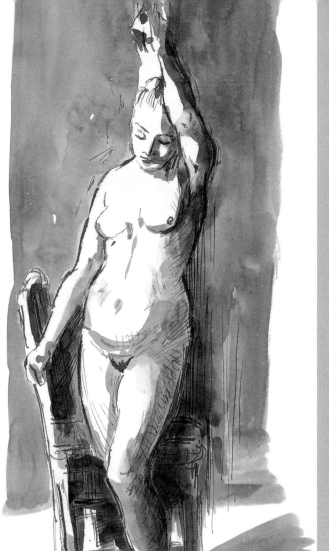

The previous chapters have dealt with elements of line, tone and texture, depicted in drawings by master artists. These elements help to convince us of the form of objects, people or scenery. Form itself is the way a draughtsman tries to convey the three-dimensional structure of an object. It is of course another illusion (like texture), but by orchestrating the marks on the surface of the drawing, the artist induces the impression of seeing a form in space. This can be done in a number of different ways, and we have by no means exhausted the possibilities of doing it here. All the artists cited in this book want to demonstrate to the viewer how any person, animal, object, or landscape may be interpreted through the marks that they set down on the paper. We all know that the surface we are looking at is two-dimensionally flat, but with great skill and understanding of how our visual sense works, these artists work to show us that two-dimensional marks can be read as three-dimensional things occupying space.

The previous sections have shown in a fragmentary way how these illusions of form and space can be produced, but of course the artist needs to keep the whole work in mind in order to put all these methods together harmoniously.

An interesting challenge, for an artist who has achieved some good results, is to create a form with an economy of marks. This is not quite as easy as it sounds, but with a bit of practice you will soon learn ways of doing it. Finding suitable master drawings is part of the fun, and then you learn to copy their methods without merely reproducing their drawings. Don't be afraid to copy the masters until you find out how they worked in detail.

*Both the artists shown here have made magnificent studies of animals in action and repose, and these two examples show how a carefully faceted version by* **Delacroix** *and a more linear version by* **Victor Ambrus (b. 1935)**. *Both manage to convey the weight and dimensional aspects of these animals.*

Delacroix was a pupil of Guérin, a follower of the great neo-classicist David. It was from this tuition that he gained an understanding of line, mass and movement which he exploited in his more adventurous drawings. In this study he skilfully suggests, in a few rapidly drawn lines, the tone and weight of the lion. Delacroix travelled widely and carried his sketchbooks with him wherever he went, to the great advantage of both his own art and that of his followers.

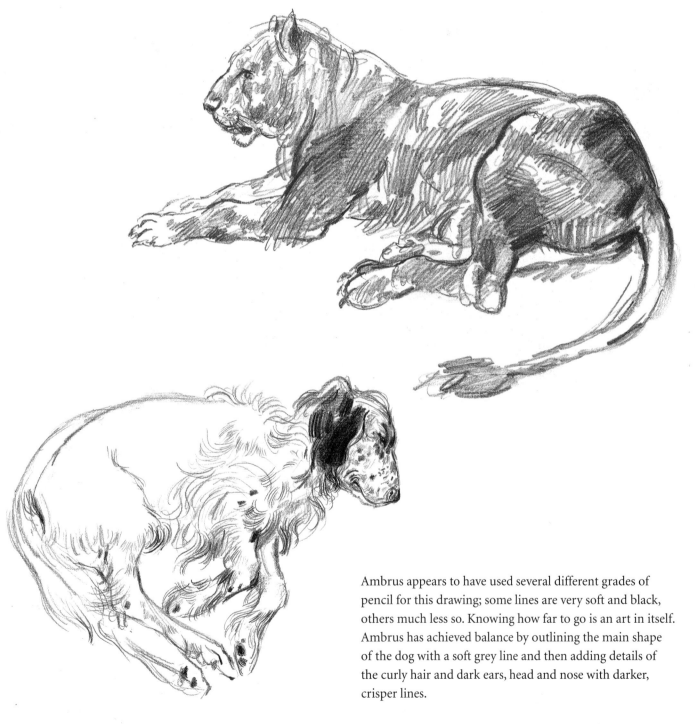

Ambrus appears to have used several different grades of pencil for this drawing; some lines are very soft and black, others much less so. Knowing how far to go is an art in itself. Ambrus has achieved balance by outlining the main shape of the dog with a soft grey line and then adding details of the curly hair and dark ears, head and nose with darker, crisper lines.

## Raphael

The perfection of Raphael's drawings
must have seemed extraordinary to
his contemporaries, even though they
had already seen the works of Filippo
Lippi, Botticelli, Michelangelo and
Leonardo. His exquisitely flowing lines
show his mastery as a draughtsman;
notice the apparent ease with which
he outlines the forms of his Madonna
and Child, and how few lines he needs
to show form, movement and even
the emotional quality of the figures
he draws. His loosely drawn lines
describe a lot more than we notice
at first glance. It is well worth trying
to copy his simplicity, even though
your attempts may fall far short of the
original. The originals are unrepeatable,
and it is only by studying them at first
hand you will begin to understand
exactly how his handling of line and
tone is achieved.

*Pen and ink is special in that once you've put the line down it is indelible and can't be erased. This really puts the artist on his mettle because, unless he can use a mass of fine lines to build a form, he has to get the lines 'right' first time.*

*Once you get a taste for using ink, it can be very addictive. The tension of knowing that you can't change what you have done in a drawing is challenging. When it goes well, it can be truly exhilarating.*

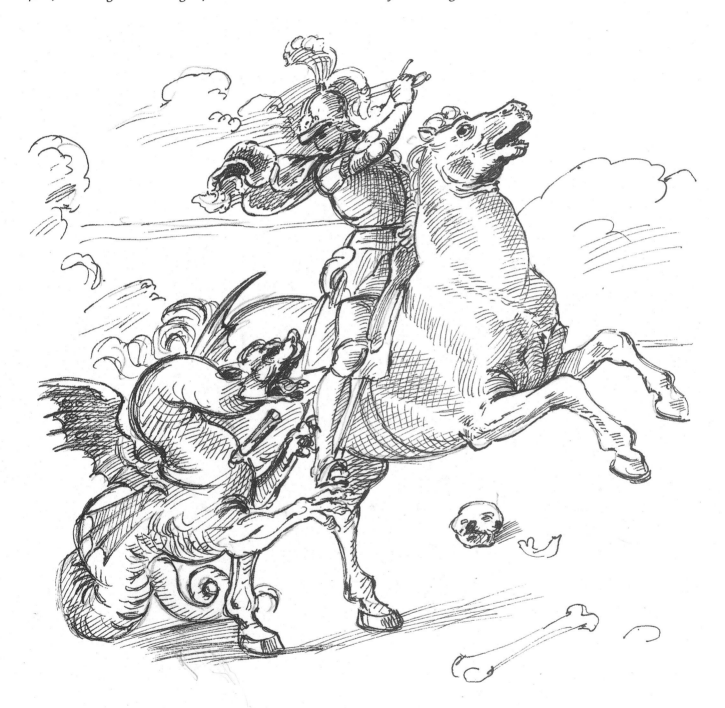

This copy of another Raphael is more heavily shaded in a variety of cross-hatching, giving much more solidity to the figures despite the slightly fairy-tale imagery. The movement is conveyed nicely, and the body of the rider looks very substantial as he cuts down the dragon. The odd bits of background lightly put in give even more strength to the figures of knight, horse and dragon.

*Here we look at the effects of form that can be obtained by using a mixture of pen and brush with ink. The lines are usually drawn first to get the main shape of the subject in, then a brush loaded with ink and water is used to float across certain areas to suggest shadow and fill in most of the background to give depth.*

*A good-quality solid paper is necessary for this type of drawing; try either a watercolour paper or a very heavy cartridge paper. The wateriness of the tones needs to be calculated to the area to be covered. In other words, don't make it so wet that the paper takes ages to dry.*

**Rembrandt**'s handling of form is remarkably straightforward and very effective. The washed tone and the slight scratchy texture of the figure and background clearly shows us the form of the posed female body in a room lit by a direct side light. This copy of a Rembrandt is very dramatic in its use of light and shade.

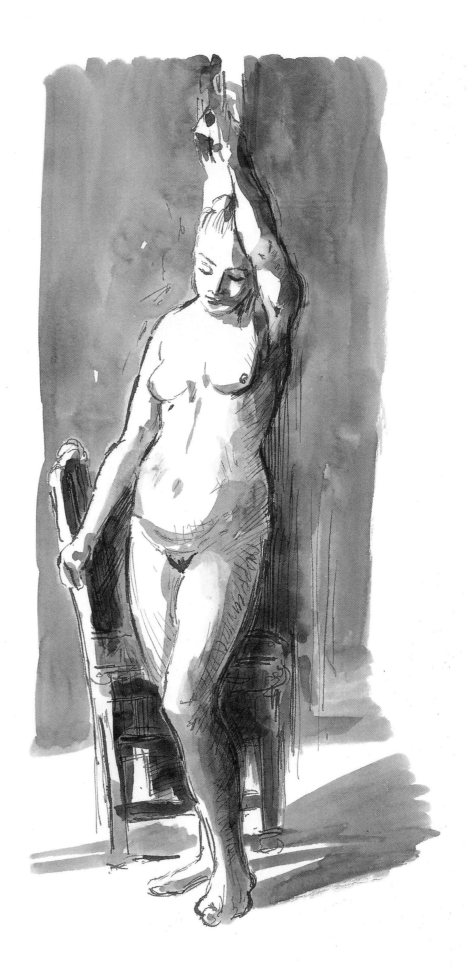

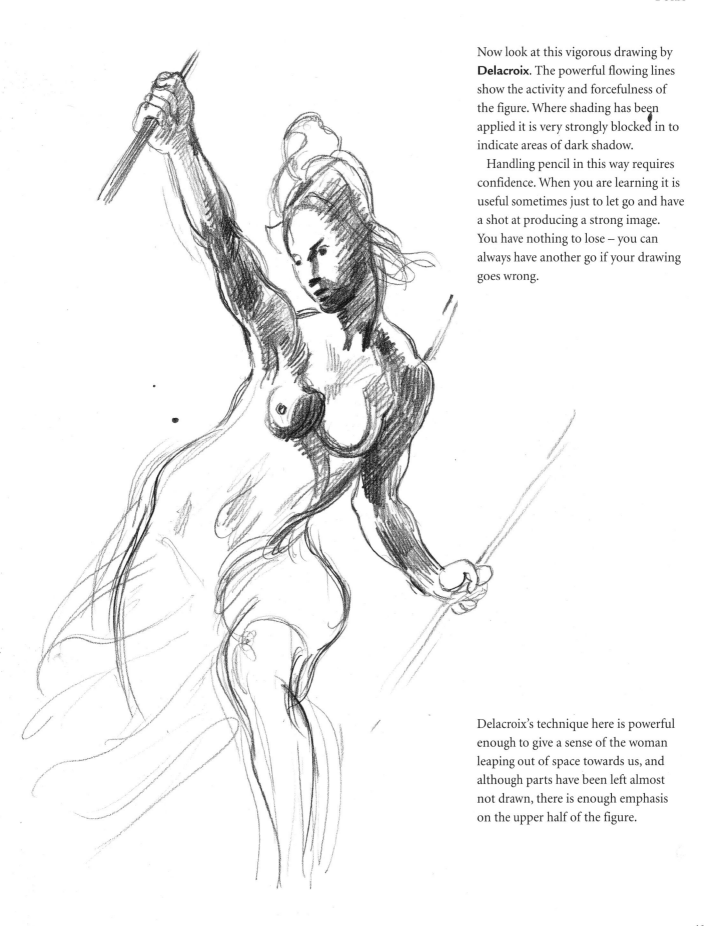

Now look at this vigorous drawing by **Delacroix**. The powerful flowing lines show the activity and forcefulness of the figure. Where shading has been applied it is very strongly blocked in to indicate areas of dark shadow.

Handling pencil in this way requires confidence. When you are learning it is useful sometimes just to let go and have a shot at producing a strong image. You have nothing to lose – you can always have another go if your drawing goes wrong.

Delacroix's technique here is powerful enough to give a sense of the woman leaping out of space towards us, and although parts have been left almost not drawn, there is enough emphasis on the upper half of the figure.

This pen and wash example, after **J.M.W. Turner**, offers
large areas of tone and flowing lines to suggest the effect of a
coastal landscape.

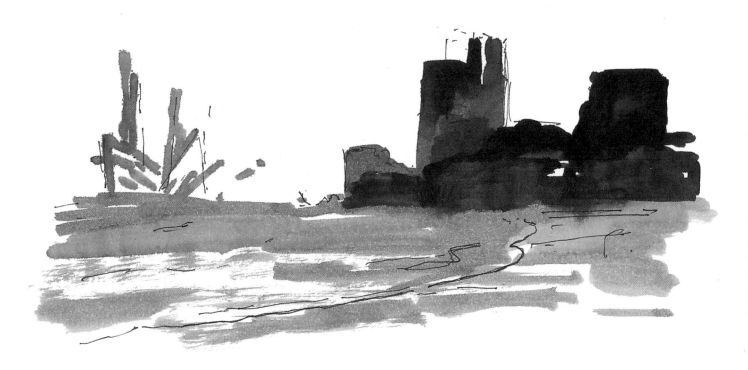

Turner's landscape implies form by the density of the splashed-on tone. The
building is solid and light-blocking, whereas the ship-like marks suggest something
much less tangible. The black mass of the buildings also sets a limit to the sweep of
grey landscape in the foreground. This helps to create a sense of perspective in the
scene, with the curve of the beach culminating in the massive castle-like structure.

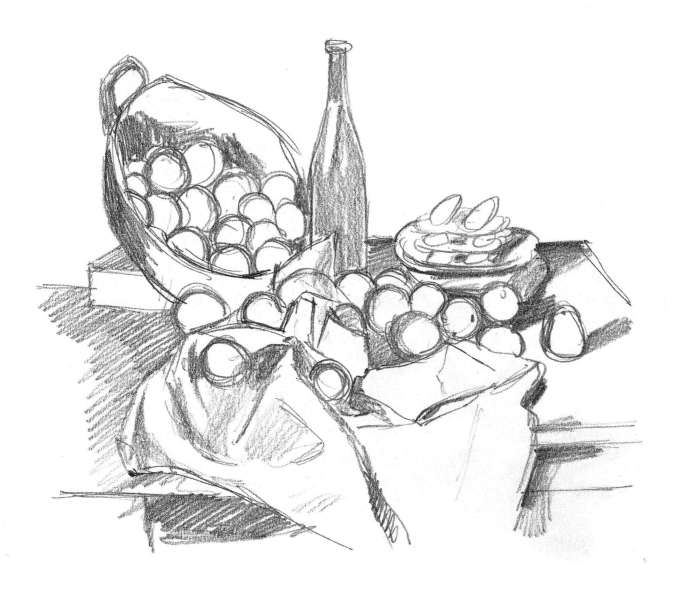

**Paul Cezanne's (1839–1906)** keen observation of the form of objects was one of his great talents. Here in this still life, although everything is drawn in the most minimal fashion, it is clear that the forms spilling across the tabletop have a solidity about them. This is a bit surprising when we see how the drawn marks are so minimal.

The bottle and folds in the tablecloth give assistance as a vertical element to the spilled abundance of fruit in the centre of the picture. The relationship of the structure of each object is submerged into the main shape and yet runs through the whole picture to make a very satisfying composition.

## Edgar Degas (1834–1917)

Degas was taught by a pupil of Ingres, and studied drawing in Italy and France until he was the most expert draughtsman of all the Impressionists. His loose flowing lines, often repeated several times to get the exact feel, look simple but are inordinately difficult to master. The skill evident in his paintings and drawings came out of continuous practice.

He declared that his epitaph should be 'He greatly loved drawing.' He would often trace and retrace his own drawings in order to get the movement and grace he was after. Hard work and constant efforts to improve his methods honed his natural talent.

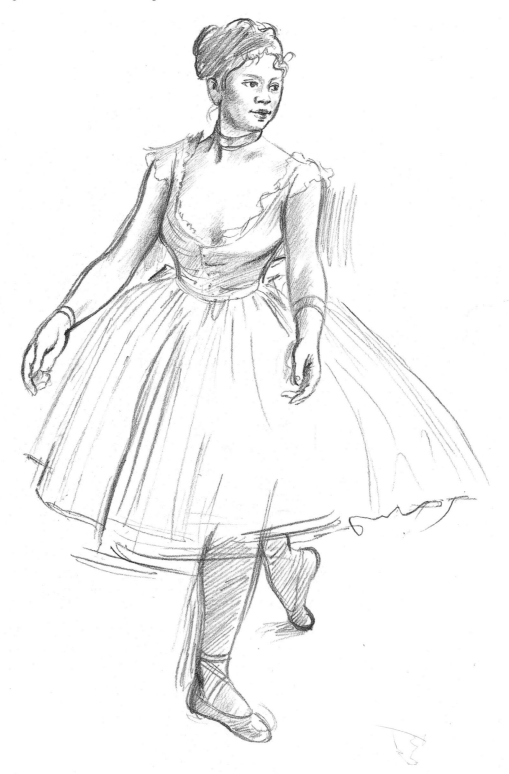

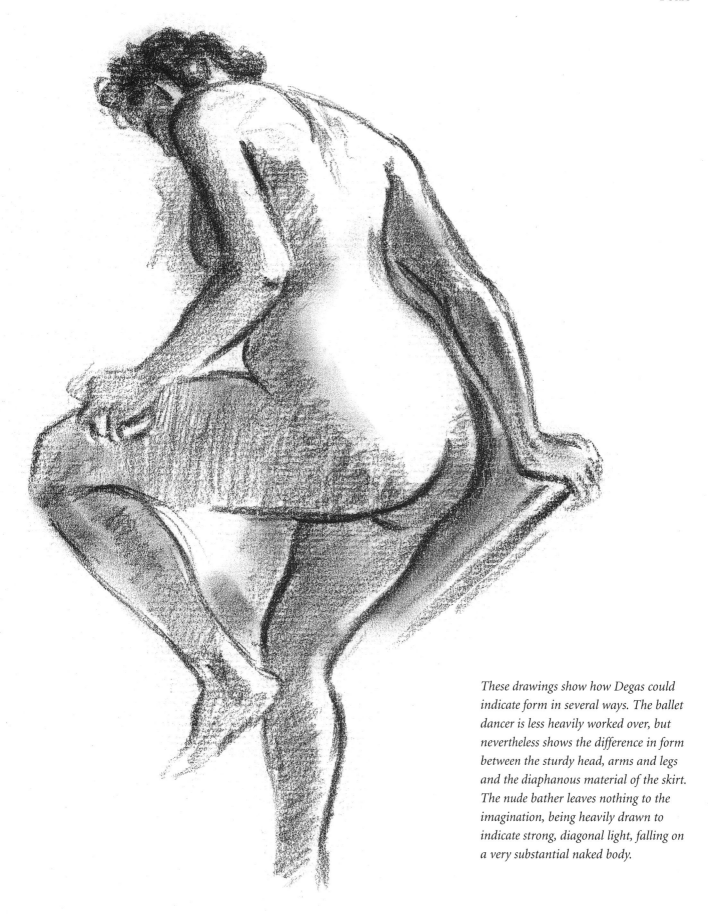

These drawings show how Degas could indicate form in several ways. The ballet dancer is less heavily worked over, but nevertheless shows the difference in form between the sturdy head, arms and legs and the diaphanous material of the skirt. The nude bather leaves nothing to the imagination, being heavily drawn to indicate strong, diagonal light, falling on a very substantial naked body.

One of the most successful of contemporary artists, **David Hockney** has been able to follow his delight in drawing the human face in an age when many artists have all but forgotten how to produce a likeness. In this copy of an original he made in 1983, the intense gaze makes it clear that he misses nothing. His handling of the form is very spare and yet highly effective. Hockney's head is drawn so that we can see its substantial roundness under a strong light with dark shadow under the chin.

# Space

This section deals with something that is not at all obvious at first glance, but once you have seen how it works, it can lend a great deal of power to your drawings. Across the surface of a picture, you can, of course, leave spaces between your marks in an effort not to crowd the scene too much, but this doesn't deal with creating the apparent space behind the surface plane of the picture. To do this, you will need to put into effect all the other techniques that you have tried out so far, and see how they can help create a feeling of depth. You will notice that the depth of tone, the strength of line, and the kind of texture you use when making your drawing marks can have quite an influence on whether something seems closer to, or

further from, the picture plane. It is particularly noticeable in landscapes how this understanding of the effects of perspective, in line and aerially, can make a huge difference to how you see the picture. A heavy line often seems much closer to the eye than one that is very faint. A dark tone can bring an object closer to you, and detailed texture can give the impression of something close-up. Conversely, lighter tones and less detailed texture can thrust an object further back into the distance. So look carefully at the way these master artists have handled their lines, tones, textures and form in order to give a convincing account of the apparent space in the picture. It is often the contrast of one mark against another that creates the right impression.

*For the artist, interior space that we find inside a house is an example of a 'controlled' visual space. Usually the doors and* *windows show no other spaces beyond the immediate room walls, enclosing and focusing the scene.*

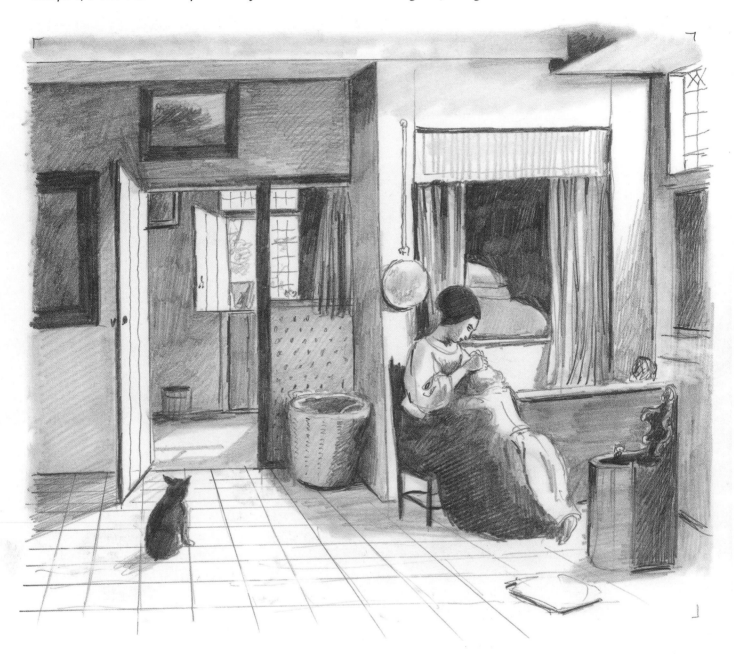

**Pieter De Hooch (1629–1684)** often included quite a large area of the inside of a house, particularly the family rooms. In this example, his interior spaces are very considered and help to create an aspect that goes through the room into the next and then out of the window to the outside world. The little dog sitting opposite the doorway draws the eye through to the larger space. The mother and daughter, placed well over to one side, sit in front of an alcove in which the bed is set, making a dark, enclosed recess. This juxtaposition of light open space and dark inner space gives the composition a lot of interest, apart from the presence of the figures.

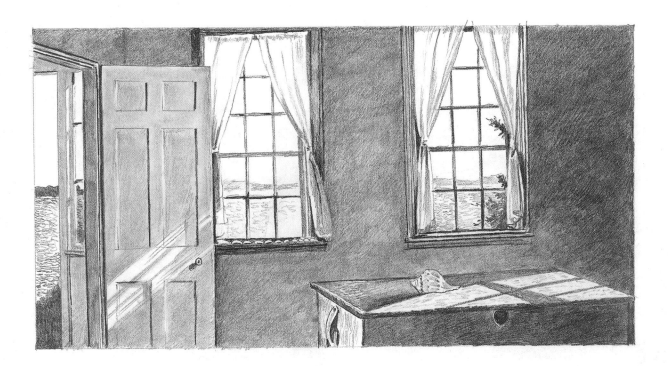

This composition after **Andrew Wyeth** shows a room with large windows and an open door leading to the sea, with the seashell on the top of the large wooden chest emphasizing the location. The emptiness of the room gives spacious qualities to a very simple but elegant still-life statement. This is a fine example of how the genre frequently suggests the movement of life which is stilled just at this minute.

An even larger space looking out through windows typifies Wyeth's picture of a milking room in an outbuilding of a New England farm. The care with which he has depicted the shiny milking pail, the old tin cup on the piece of wood and the spigot from which a stream of water pours into the worn stone sink and then drains over the edge gives an intimate picture of a piece of country life. It is simple, spacious and strongly redolent of hard, old-fashioned farm work.

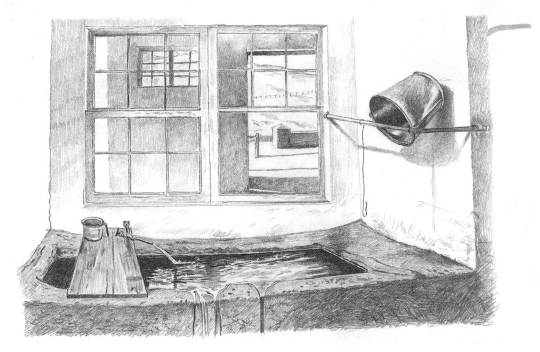

Drawing outdoor spaces presents the artist with a new range of challenges. In these two idyllic landscapes, after **Claude Monet (1840–1926)** *(below)* and **Pieter Breugel (1525–1569),** the vegetation is reduced to the minimum and the land is white with snow. This creates a strange spatial awareness, with a line of sight — the river and the trees respectively — pulling our attention into the distance. Because of the white snow and dark sky, and the silhouetted shapes against it, the actual distance is harder to judge.

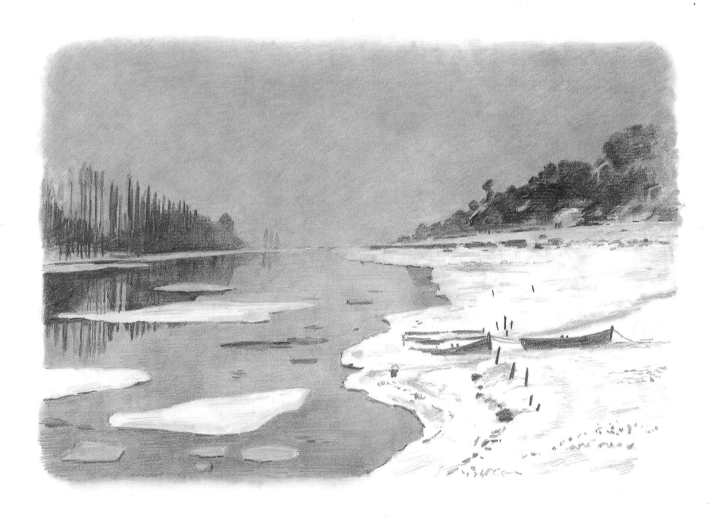

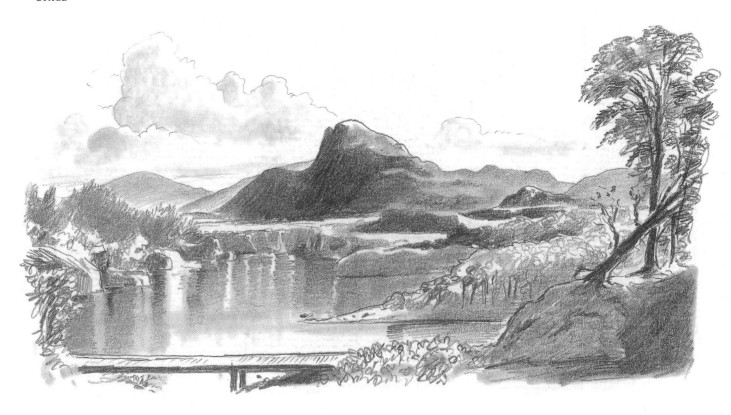

There are plenty of interesting contrasts in this example after **Frederic Edwin Church (1826–1900)**: water, trees, hills and a jetty in the front. However, the most ominant feature is the rocky hill in the middle distance standing out starkly against the skyline. This holds the attention and helps us to consider the depths shown in the picture.

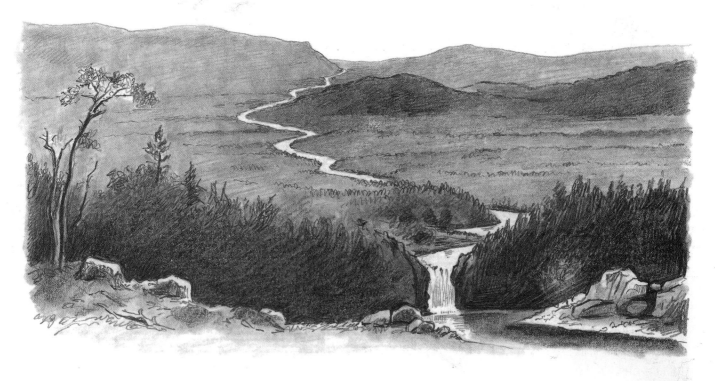

The river in this view of the Catskill Mountains after **S.R. Gifford (1823–1880)** leads the eye through the picture. The contrast between the dark tree-clad contours of the land and the brightly reflecting river draws us into the composition and takes us to the horizon.

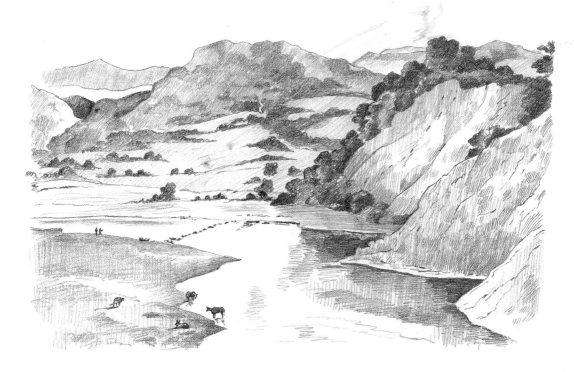

In this example after **Thomas Cole (1801–1848)** the high viewpoint allows us to look across a wide river valley to rows of hills receding into the depth of the picture. The tiny figures of people and cattle standing along the banks of the river give scale to the wooded hills. Notice how the drawing of the closer hills is more detailed, more textured. Their treatment contrasts with that used for the hills further away, which seem to recede into the distance as a result.

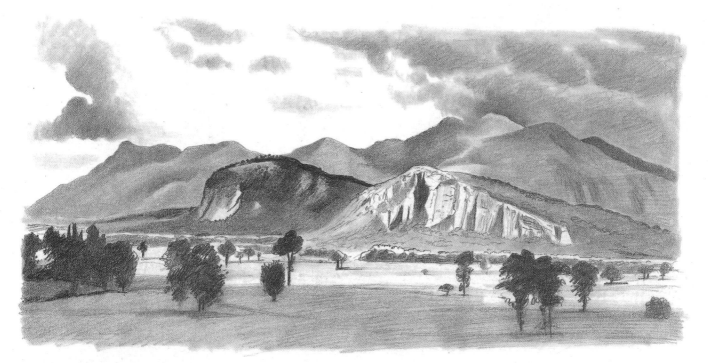

This drawing of Moat Mountain (after **Albert Bierstadt, 1830–1902**) includes several elements that combine to soften its aspect. The vegetation growing over the folds of the rocky slopes and the fairly well-worn appearance of the rocks, visible signs of glaciation in the remote past, have a softening effect. The dark clouds sweeping across the mountain tops and the silhouetted trees looming up from the plain in the foreground also help to unify the composition. This handling of foreground, middleground and background features creates a sense of monumental, timeless space.

*Both of the artists shown here understand the dynamics of spatial relationships, particularly where the human figure is concerned.* **Sidney Goodman's (b. 1936)** *composition of a group of friends produces a spacious rather empty room, grouping the* *figures around a table with a window to light it all.* **Michael Andrews (1928–1995),** *out in a garden, uses the staggered placing of his family members to produce a feeling of depth, and even the passing of time.*

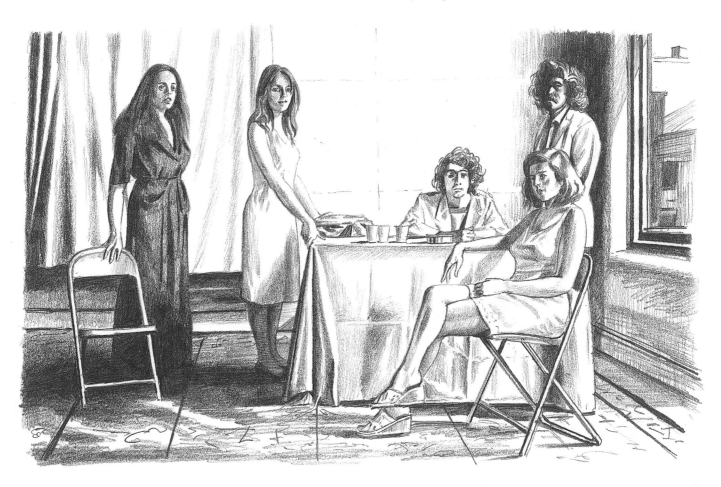

In this copy of Sidney Goodman's *Portrait of Five Figures* (1973) we see a neo-classicist emphasis on what is a very contemporary composition. The effect with the carefully arranged figures is akin to that achieved by the 19th-century French painter Jacques-Louis David in a painting called *The Death of Socrates*, which is grouped and lit in a similar way. However, in this example the people are looking at the viewer, so it is obviously meant to be a portrait. The significance of the picture would be lost on most viewers. The symbolism relates directly to art itself and the fact that this is a modern version of a school of painting last seen in revolutionary France at the beginning of the 19th century. Harking back to the work of earlier artists is a constant theme in the history of art. Most artists have taken this path at some point, as a way of discovering new possibilities. The insight gained by trying to incorporate a work that you admire into your own can be of immense benefit to the development of your own style.

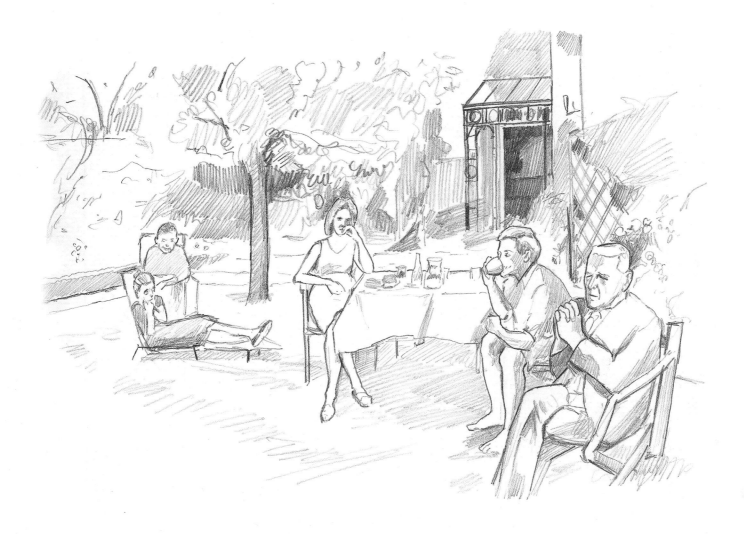

This is a copy of one of Michael Andrews's first large pieces of work, a group portrait of his family in their garden in Norfolk on a summer afternoon. The original painting is at least 1.8 m (6 ft) high and took two years to complete.

After drawing up a sketch, which gave him the positions of the individuals, Andrews then had to make more careful individual studies. He also worked from photographs. The final picture is quite a dynamic composition, spread across the canvas and in some depth from front to back. The drawing of the figures has been kept relatively simple, with the two nearest the viewer the most precisely detailed.

# How to do it

Here we look at some of the details of drawing techniques that artists use in their search to produce good pictures. We see how the artist can apply the techniques to advantage, and bring some real skill to bear on the production of significant mark-making. The materials are important and will give the picture the particular look which is required by the artist. The handling of materials is not difficult, but it does need practice in order not to look laboured. You will also have to consider how you build up a picture, so that it proceeds in a fashion that doesn't have you regretting the first marks that you made when you get to the last.

It cannot be stressed too much how important regular practice is to produce drawings that you will be proud to have achieved. The more you practice, the quicker will come the sort of results that will please you. Don't forget to try out different materials as well, because each attempt with new materials helps to increase your understanding of those that you have already used.

*These drawings by a master of impressionism show how human character and presence can be conveyed even in a sketchy manner.*

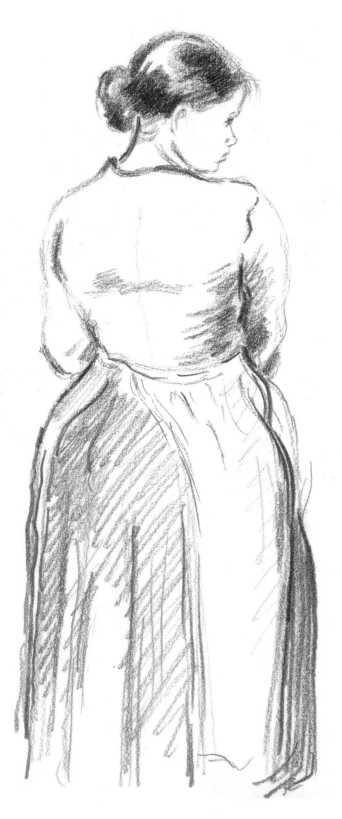

**Camille Pissarro's (1831–1903)** young peasant woman is drawn with the maximum of economy and the minimum of marks on the paper. Although the lines are very sparse there is no doubt in our minds that this is a substantial young woman with sturdy limbs and torso. The shoulders look strong and the waist solid. Although there are probably layers of petticoats under the skirt, it looks as though she is probably well developed in the hip area as well. Our eyes fill in all the spaces to see her as the artist did.

### Diego Velázquez (1599–1660)

Now that you've looked at how the human figure can be expressed with the minimum of marks, try drawing from a famous classical figure painting, **Velázquez**'s *The Toilet of Venus* (also known as 'The Rokeby Venus'), using tone to increase the dimensional qualities of your drawing.

Pay attention to the direction of the light source, as this will tell you about the shape of the body. Keep everything very simple to start with and don't concern yourself with producing a 'beautiful' drawing. Really beautiful drawings are those that express the truth of what you see.

*1. Sketch in the main outline, ensuring that the proportions are correct. Note the lines of the backbone, shoulders and hips. Check the body width in relation to the length and the size of the head in relation to the body length. Pay special attention also to the thickness of the neck, wrists, ankles and knees. All of them should be narrower than the parts either side of them.*

*2. Finalize the shape of the limbs, torso and head. Then draw in the shapes of muscles and identify the main areas of tone or shadow.*

*3. Carefully model in darker and lighter tones to show the form. Some areas are very dark, usually those of deepest recession. The highlights or very light areas are the surfaces facing directly towards the source of light and should look extremely bright in contrast to any other area.*

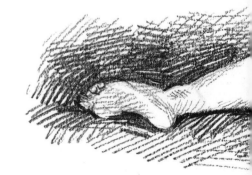

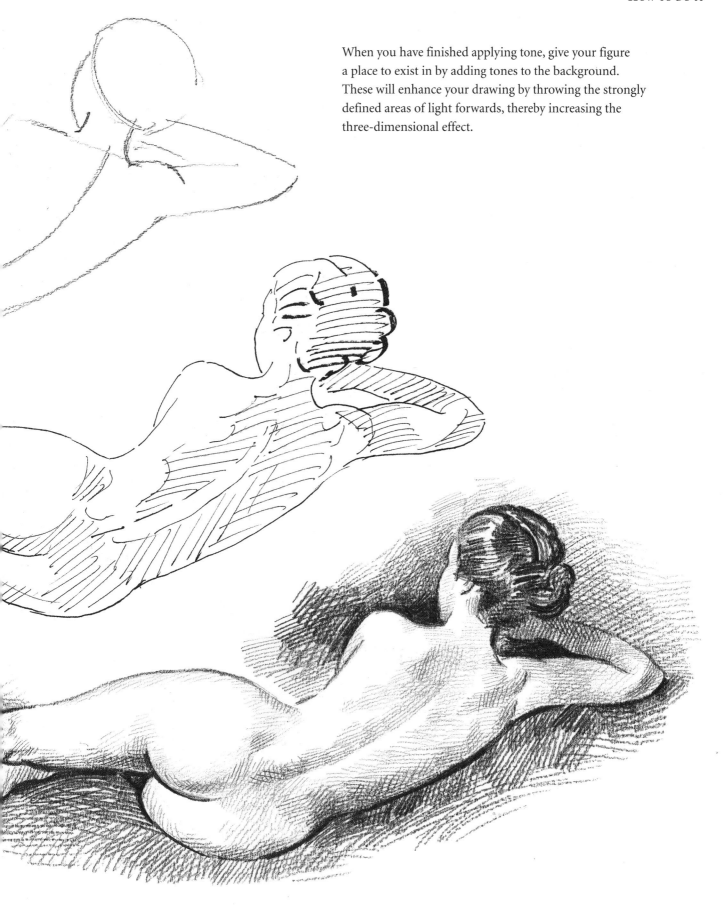

When you have finished applying tone, give your figure
a place to exist in by adding tones to the background.
These will enhance your drawing by throwing the strongly
defined areas of light forwards, thereby increasing the
three-dimensional effect.

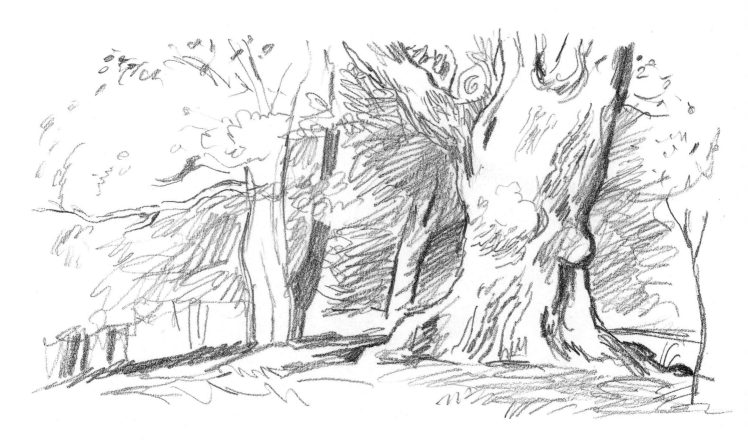

The pencil work used for this large old tree in a wood (after
**Samuel Palmer, 1805–1881**) is loose in technique. At the
same time, however, it is very accurate at expressing the growth
patterns of the tree, especially in the bark. It is best described
as a carefully controlled scribble style, with lines following the
marks of growth.

*As well as the pencil, the pen is a subtle and versatile medium for drawing. Generally speaking any fine-pointed nib with a flexible quality to allow variation in the line thickness is suitable for producing landscapes.*

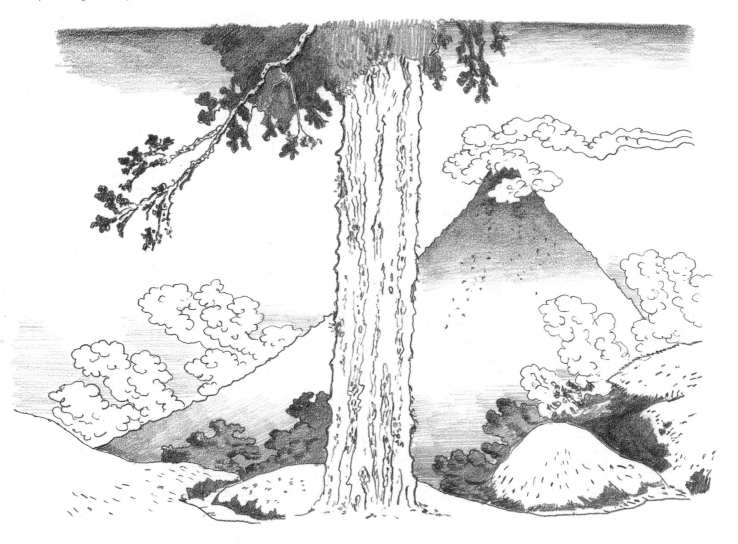

For his original of Mount Fuji the Japanese artist **Katsushika Hokusai (1760–1849)** probably made his marks with a bamboo calligraphic nib in black ink. I have made do with pen and ink, but even so have managed to convey the very strong decorative effect of the original. Note how the outline of the tree trunk and the shape of the mountain are drawn with carefully executed lumps and curves. Notice too the variation in the thickness of the line. The highly formalized shapes produce a very harmonious picture, with one shape carefully balanced against another. Nothing is left to chance, with even the clouds conforming to the artist's desire for harmonization. With this approach the tonal textures are usually done in wash and brush, although pencil can suffice, as here.

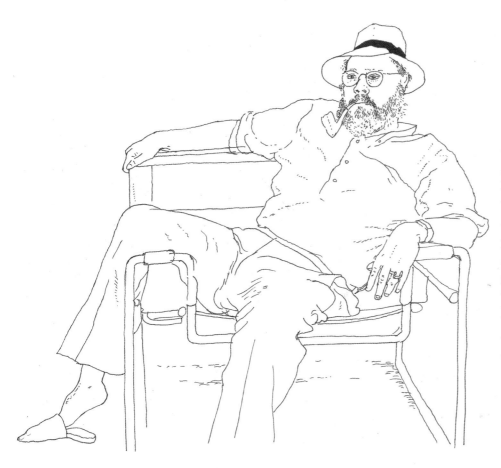

**David Hockney**'s picture of Henry Geldzahler (left), drawn in Italy in 1973, shows his friend relaxing in a big tubular steel chair out in the garden, straw hat and all. Geldzahler liked posing for his portrait and so was always keen to arrange himself in an interesting attitude. The thin, even pen line has a precision about it, but is also quite sensitive to the quality of the material of the clothes and the hair. The slightly cautious, meandering quality of the line gives a feeling of care and attentiveness in the drawing. This style is simple but extremely effective.

■ *Hockney's medium here is a fine-line graphic pen.*

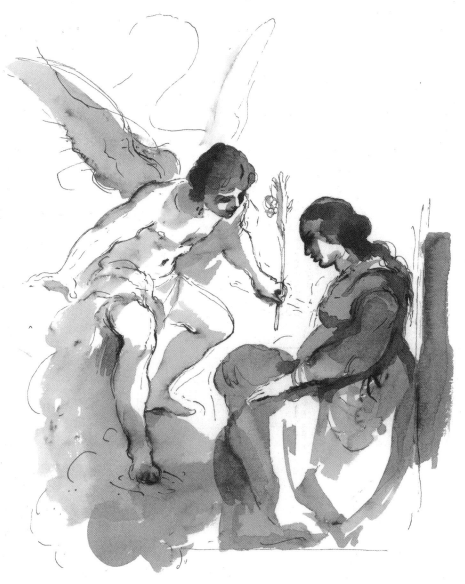

This drawing made by the Italian master **Guercino** in 1616 was a sketch for a small devotional picture of the Annunciation with the Archangel Gabriel descending from heaven bearing a lily, symbol of Mary's purity. The line in ink which Guercino uses to trace out the figures is very attractive, because although it is sensitive it also has a confidence about it which shows his great ability. The drawing has areas of tone washed in with watered-down ink and the wet brush has also blurred some of the lines, as the ink is not waterproof. His handling of dark areas contrasting with light is brilliant, and shows why his drawings are so much sought after by collectors.

This illustration shows the use of pen with wash, alternating the fine line of the pen with the floating on of tone which blurs some of the areas where roundness is needed.

*Chalk-based media, which include conté and hard pastel, are particularly appropriate for putting in lines quite strongly and smudging them to achieve larger tonal effects, as you will see from the example shown, after* **Cézanne**.

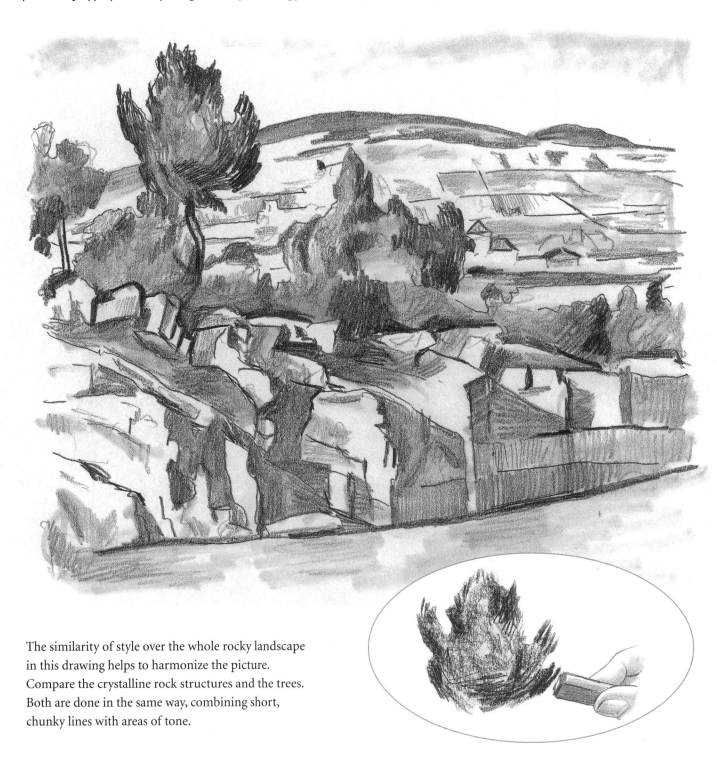

The similarity of style over the whole rocky landscape in this drawing helps to harmonize the picture. Compare the crystalline rock structures and the trees. Both are done in the same way, combining short, chunky lines with areas of tone.

*The use of different media is very much a question of choice by the artist, but it is a good idea to try out a few to give you an idea about which techniques you may want to use when confronted by decisions in drawing.*

**Degas**'s pastel drawing of a ballet dancer practising pointe exercises is one of many he produced during the 1860s. His brilliant use of pastel gives great softness and roundness to the form and his masterly draughtsmanship ensures that not a mark is wasted. This is a very attractive medium for figure studies because of its speed in use and the ability to blend the tones easily.

Pastel goes on quite quickly and easily but a careful handling of the tonal areas is necessary to build up the tone rather than try to achieve the final result in one attempt.

*Beginners generally do not get on well with brush and wash. Watercolour, even of the tonal variety, demands that you make a decision, even if it's the wrong one. If you keep changing your mind and disturbing the wash, as beginners tend to do, your picture will lose its freshness and with it the most important quality of this medium.*

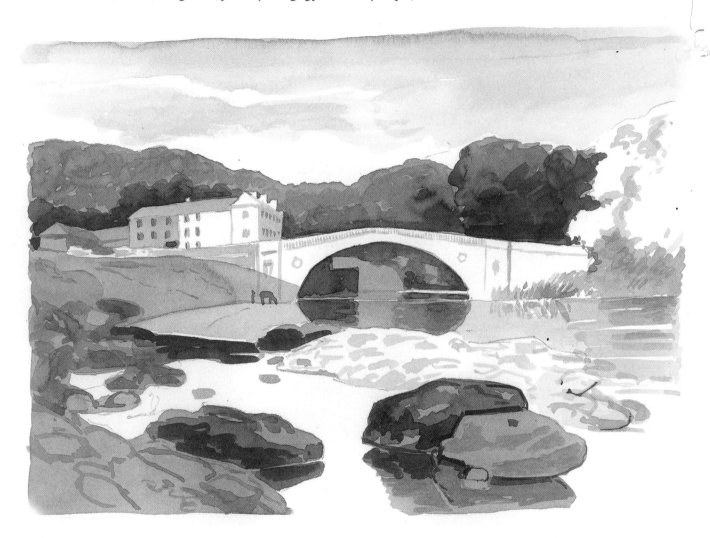

In *Gretna Bridge* (after English watercolourist **John Sell Cotman, 1782–1842)** the approach is very deliberate. The main shapes of the scene are sketched in first, using sparse but accurate lines of pencil, not too heavily marked. At this stage you have to decide just how much detail you are going to reproduce and how much you will simplify in the cause of harmony in the finished picture. Once you have decided, don't change your mind; the results will be much better if you stick to one course of action. The next step is to lay down the tones, starting with the largest areas. When these are in place, put in the smaller, darker parts over the top of the first, as necessary. You might want to add some finishing touches in pencil, but don't overdo them or the picture will suffer.

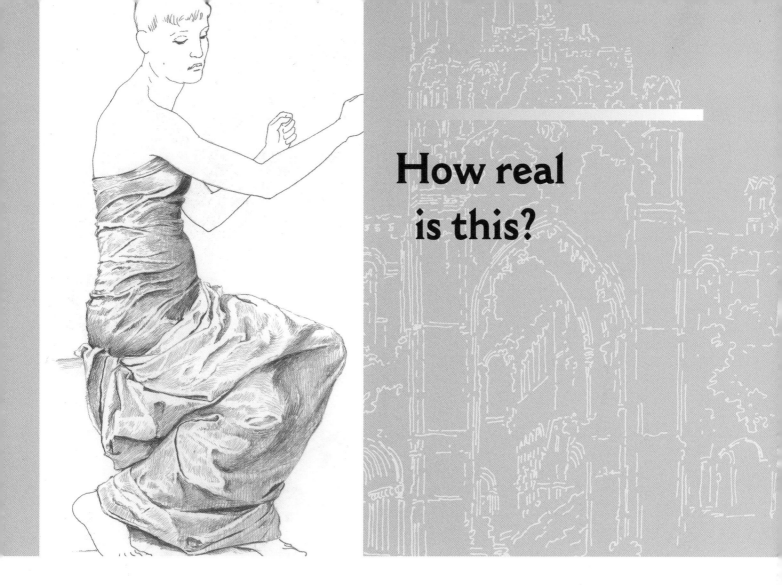

# How real is this?

The works in this section are in the nature of a series of *tours-de-force*, where the artists have shown their skills in a particularly impressive way. Not all are well-known, but by virtue of the piece shown, they are fine examples of super-illusionist pictures that pack a punch by their skill. From the Renaissance onward, many artists worked in the *trompe l'oeil* method, which aimed to produce a picture so realistic that, at first glance, people would think it was the real thing. This usually meant that it would have to be placed in a way that already suggested it was the actual object. It was a sort of art joke, and was intended to raise pleasantly surprised laughter, as well as impressing by its realism. Not all of these drawings are of the *trompe l'oeil* genre but, by means of their techniques, they all have a convincing power to trick the viewer. The penultimate example (see page 73) is a nice joke that might have been kept in an artist's studio to impress his clients.

In one of the best dog portraits of the 20th century, by **Lucian Freud (b. 1922)**, the artist's first wife, Kitty, is shown with a white bull terrier cuddling up to her lap. The original was painted in tempera, a very meticulous method where you use a brush almost like a pencil, and so lends itself to depiction in pencil, as here. The whole portrait is really of Freud's wife but the dog is so clearly defined that it almost takes over the picture. The only way that the human model keeps the attention is because she has bared one breast and has enormous luminous eyes. Hundreds of tiny strokes were necessary to capture the dog's smooth but hairy coat for this copy.

Depictions of the texture of animal skin and the materiality of cloth is often the time when an artist can show off the ability to produce a quality of drawing that is as convincing as a photograph. This detailed working over of a large area of texture in this way can often be a most powerful tool in convincing the viewer of the reality of the subject.

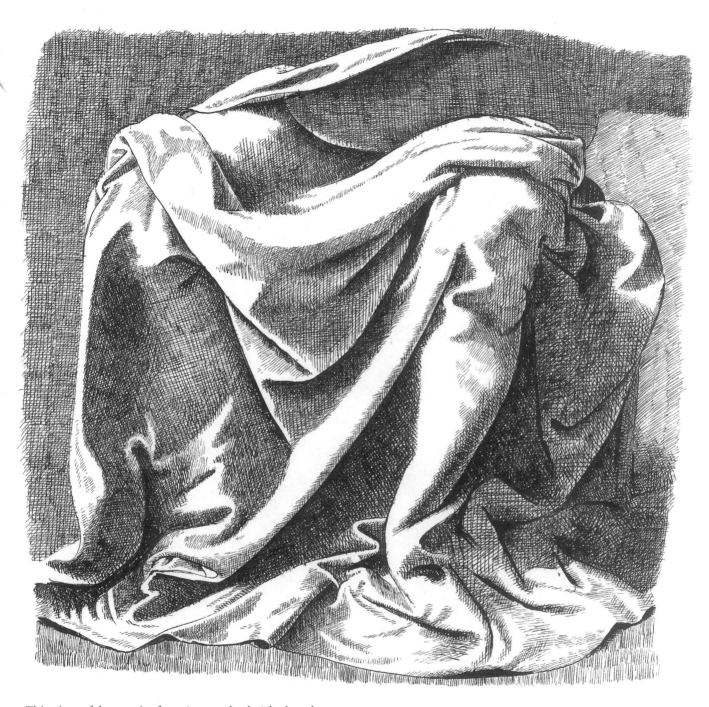

This piece of drapery is after a **Leonardo da Vinci** study.
Rendered in a painstaking ink technique of hatched lines,
it is a very classically inspired piece of work. A fine pen nib
lends itself very well to this sort of drawing, although there
were at least two grades of nib size used here in order to
obtain this effect.

*These two pages show how the human body can be represented quite graphically, either by the way the form is dressed or, at the opposite extreme, disguised to appear very different from its real form. This interesting variation on the use of clothing to portray or distort the figure has been noticeable throughout history, with costume moving from one extreme to the other over the centuries.*

In this example the artist **Otto Greiner** dressed his model in such a way as to show clearly how the female figure looks, wrapped in fabric which accentuates her shape. The lateral wrinkles and folds pulled tightly around the body give a very sharply defined idea of the contours of the torso, while the softer, larger folds of the cloth around the legs show their position but simplify them into a larger geometric shape so that the legs form the edges of the planes of cloth.

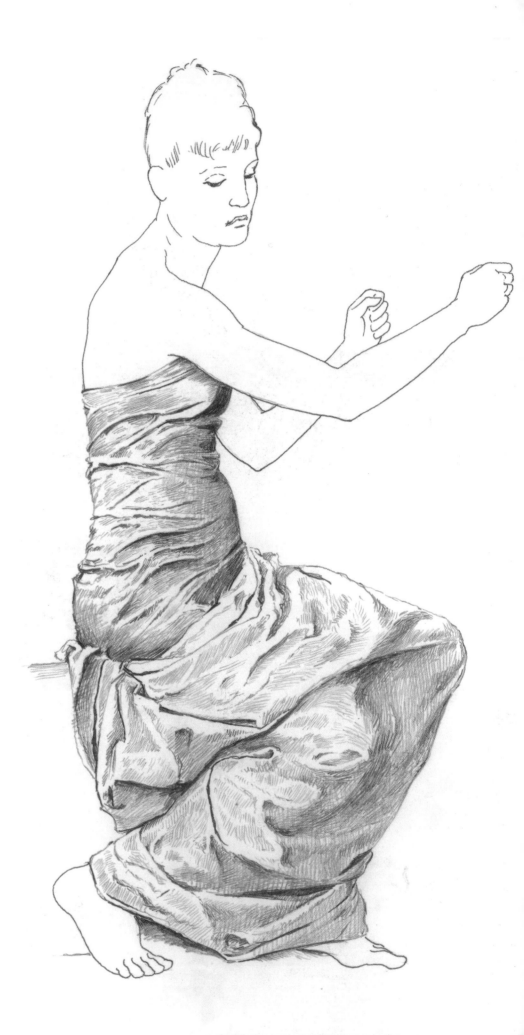

This figure after **Lucian Freud** is covered by a raincoat, jumper and trousers, which go a long way towards disguising the figure beneath. The only clear indication of the figure is at the shoulders and where the arms bend, so we can tell that the subject is quite thin. The coat is loose and thick enough to create heavy folds around the body. The trousers are also loose and shapeless and we could be looking at a mere skeleton hidden by clothing. It is not an easy task for the artist to see such a figure beneath the costume, but Freud is a significant artist who has still managed to give some feel of the body.

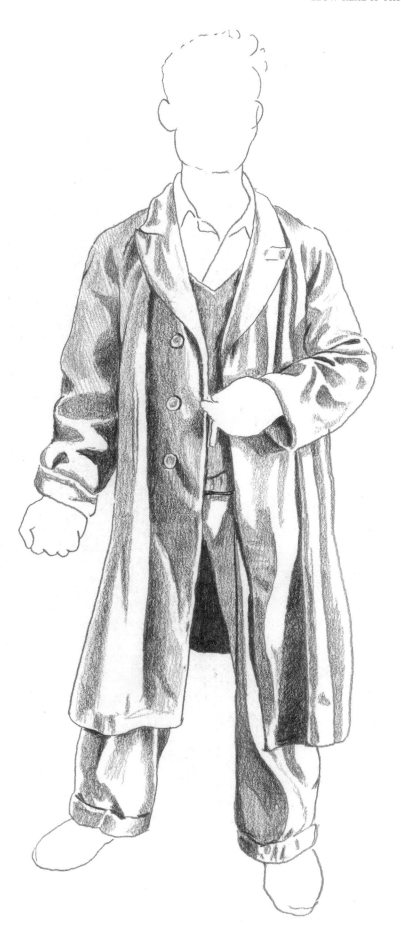

*Inanimate objects, all of one type, can help to give verisimilitude to the picture, because this piles on the effect repeatedly and lulls our more critical response.*

This composition by an 18th-century master shows shelves of music books and some musical scores. It refers to a musical theme, but has a scholarly look because this is where the composer is working to produce the raw material that instruments will eventually play.

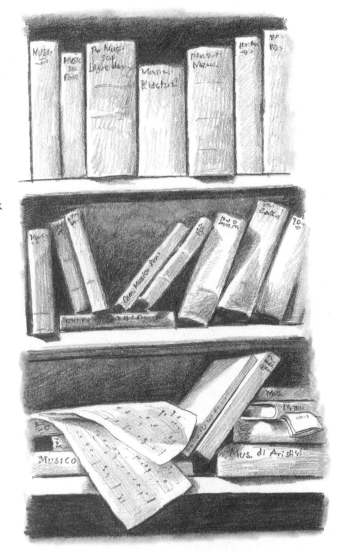

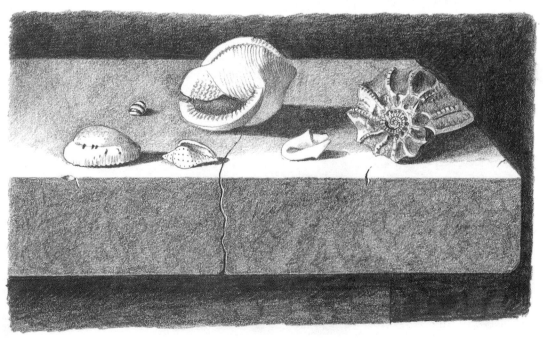

In the still life of seashells on a shelf by **Adrian Coorte (1685–1723)**, the sea is nowhere to be seen. The elegant beauty of these sea creatures' exo-skeletons makes an attractive picture in its own right, apart from the pleasing connotations of the ocean.

The typical joke of the *trompe l'oeil* painter is one that we can really enjoy being deceived by.

This picture by **Cornelius Gijsbrechts (c.1610– c.1678)** is one of the oddest and most amusing still-life subjects I have ever come across. It is apparently the reverse of a framed canvas, but is in reality an image in a trompe l'oeil manner actually painted on the surface of a canvas. Presumably the other side of it looks the same but is the real back of the picture. It is a nice joke, which probably works better as a painting than a drawing, but I could not resist including it as a remarkable piece of still-life composition that plays with reality.

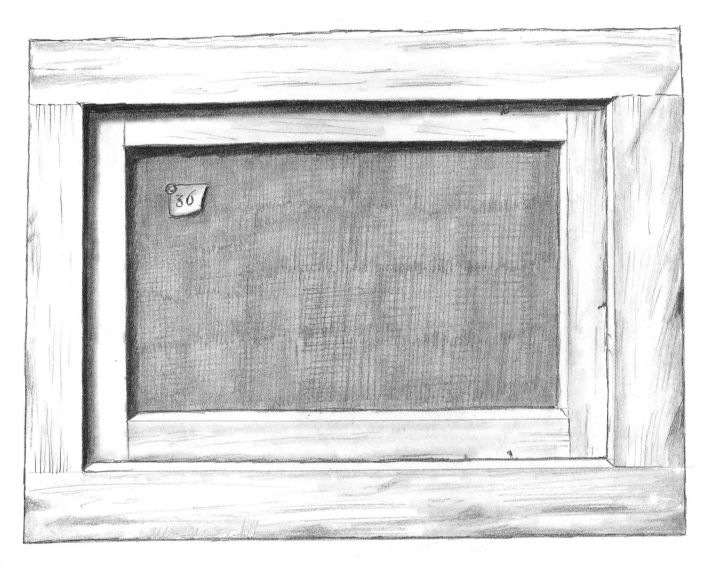

When trying to capture a realistic skyscape there is always the problem that the cloud formations and the light will keep changing. The easiest sky is of course a completely clear one, but it is quite interesting to try to show something more of the weather than just halcyon days. The feeling of reality that can be worked into a clouded sky is very attractive to an artist, because if he or she gets it right a lot of the rest of the picture will also seem more convincing. However clouds are difficult because of their diaphanous nature, and it is all too easy to make them look too solid, which rather spoils the effect.

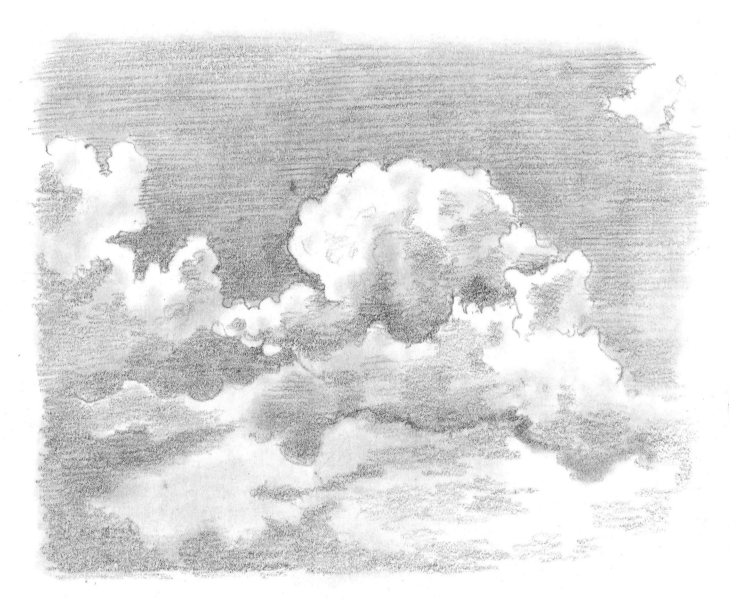

Some studies, such as this one originally by **Willem van de Velde II (1633–1707)**, were of interest to scientists as well as artists and formed part of the drive to classify and accurately describe natural phenomena.

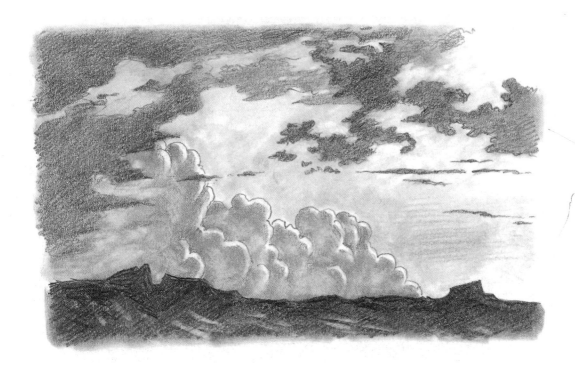

The cloud effects are the principal interest in this work after **Alexander Cozens (1717–1786)**. The three evident layers of cloud produce an effect of depth, and the main cumulus on the horizon creates an effect of almost solid mass.

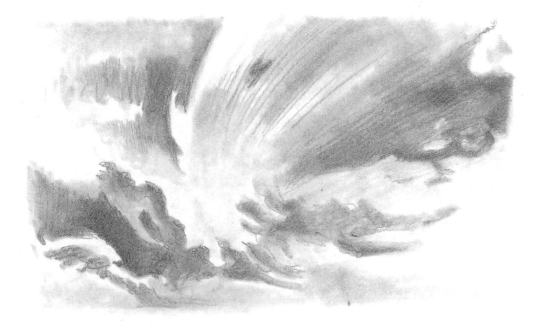

Together with many other English and American painters, **J.M.W. Turner** was a master of using cloud studies to build up brilliantly elemental landscape scenes. Note the marvellous swirling movement of the vapours, which Turner used time and again in his great land- and seascapes.

# Style

We recognize the moment when a beginner wants to achieve a certain style in their art, and this is quite natural. However, it is important to realize that true style doesn't come from merely wishing to have one but by honing all your skills in order to be able to draw whatever you like, without worrying about how you fit into the stylistic canon. Most great artists started drawing like their teachers and only evolved a style of their own over a significant number of years. So, what we are discussing is not some fleeting desire to be stylish, but a long struggle to draw the world as the artist sees it.

All the styles shown here are the result of many years of practice and have evolved from the artists' own view of life, and how they think that they should interpret it. Some are more naïve or more abstracted in their approach, others are very decorative, but all have arrived at their particular point of view from a long process of refinement. So, if you are a beginner, try not to concern yourself too much with your own style but go for some of those shown here to see if you naturally want to follow a particular system. Anyway, it is good for your practice to experiment with different styles, because it can reveal how competent you are at your stage of development.

*This is, in a way, a romantic evocation of a building: the nostalgia for a past steeped in history and mysterious forms that are now difficult to achieve.*

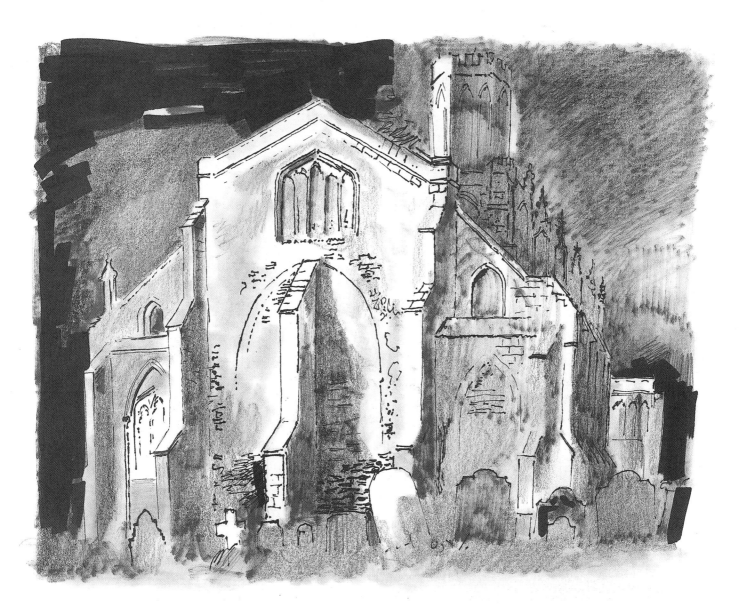

In this copy of **John Piper**'s **(1903–1992)** view of Fotheringay Church at night, the building is etched sharply against a very dark sky, with the architectural outlines of the main shapes put in very strongly. The texture of the crumbling surface of the old church is well judged, as is the decorative effect provided by the mouldings around the doors and windows. The depth and contrast in the shadows ensures that the effect of bright moonlight comes across well.

The Japanese landscape painter **Hiroshige (1797–1858)** took his forms from nature but was more interested in the spirit or essence of his scenes as works of art. He didn't want to produce simple facsimiles of what he saw. He looked for the key points and balance in elements of his choosing and then carefully designed the landscape to influence our view. Only the most important shapes and how they related to each other were shown. Usually their position and place was adjusted to imbue the picture with the most effective aesthetic quality. The landscape was really only a starting point for the artist, whose understanding, perception and skill were used both to bring the picture to life and to strike the right vibration in the onlooker. The experience was not left to accident.

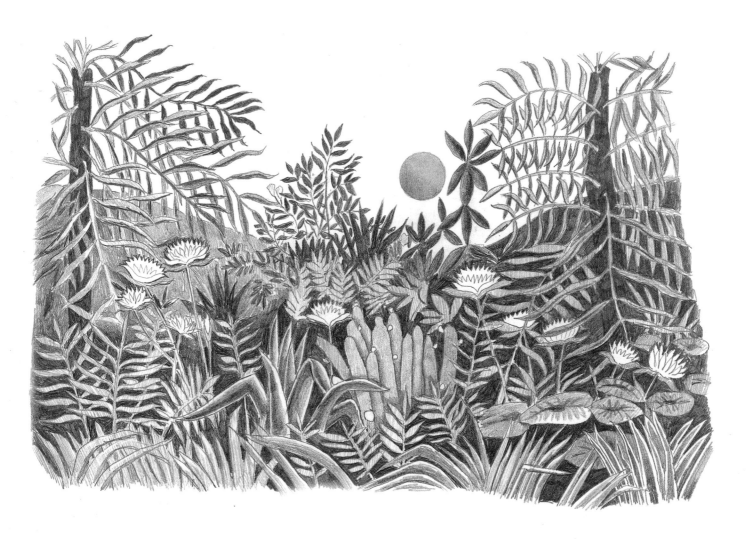

There is no disguising that *Virgin Forest at Sunset* after **Le Douanier Rousseau (1844–1910)** is an imaginary scene. The lush vegetation conveys the feel of the jungle, although the plants themselves look very much as though they have been copied from the engravings that were current at this time in geographical books and magazines. The artist probably also supplemented his knowledge by visits to the botanical gardens in Paris. In the original, figures and animals are set within the carefully composed disorder of luxuriant plants; they are left out in this version. Although this is obviously the view of an urban dweller and naïve in style, the overall effect is very impressive.

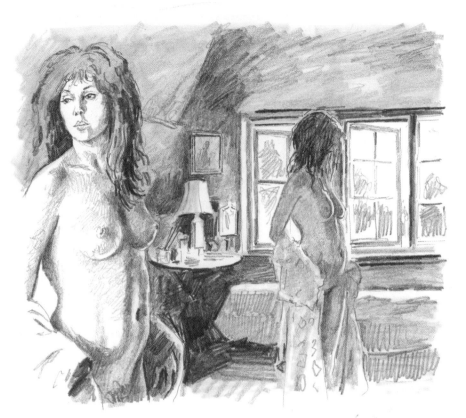

In the **Peter Kuhfeld (b. 1952)** composition shown here, the nude girl in his studio faces towards the window, casting a reflection in a large mirror behind her that shows her opposite side and the window looking out across gardens.

In effect we see two figures from different angles. This creates depth and added interest in the picture and we feel we only need to see a little more to one side to view the artist also mirrored in the scene.

In this outdoor scene, also by Kuhfeld, a girl is seated reading at a table in the garden. She is surrounded by flowers and foliage and there is just the indication of a window in the background. The table has been used for refreshments and perhaps once again the presence of the artist is hinted at in the utensils on the table. As with the nude girl in the studio, this is a very intimate scene but the enclosed space is now outside and we understand the open-air feel with the expanse of white tablecloth, iron chairs and abundant surrounding vegetation.

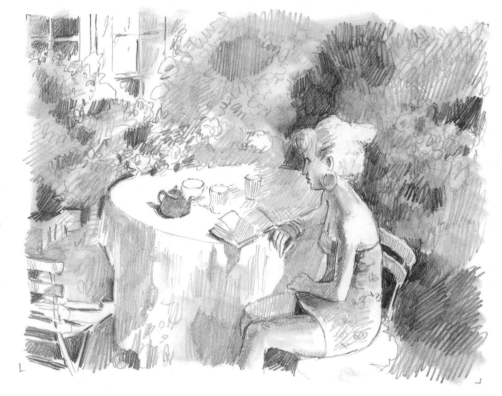

*Some artists take a representational way of drawing and then present it in an especially intimate fashion. The careful arrangements are obviously not totally natural, but look natural enough to be believable.*

In **Lucian Freud**'s double portrait of himself and his wife in a Parisian hotel bedroom, the poses are as informal as the situation is ambiguous. Why is she in bed and he standing by the window? Obviously he needed to be upright in order to produce the portrait but he hasn't shown us that he is the artist. There is no camera, sketchbook or easel and brushes in his hands. So what could be his intention? There is an explanation that Freud's wife was ill in bed at the time, so it may have been that he hit on the arrangement because it was the only way he could paint them both. In the hands of a first-class artist this unusual approach has become a groundbreaking idea. The slightly accidental look of the composition is very much of the period in which it was painted (the 1950s).

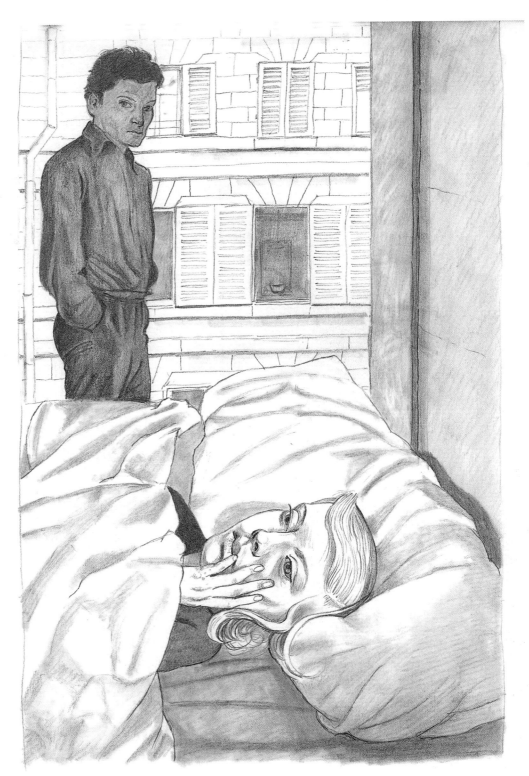

Shown here is a drawing after **Thomas Gainsborough (1727–1788)**, a master draughtsman capable of creating form with very little in the way of significant marks. He managed to convey bulk and solidity without having to labour the point with highly detailed contour hatching.

The Gainsborough is of a fashionable lady drawn at Richmond, glancing back at the artist as she walks past in her beautiful floating silk dress and big black hat. The solidity of the body under the garments is implied by little touches of chalky lines, smudged tones and white body colour, which tells us of the fascinating form of this rather coquettish young woman. What is very obvious is that this is a human body, youthful and light-footed but also substantial.

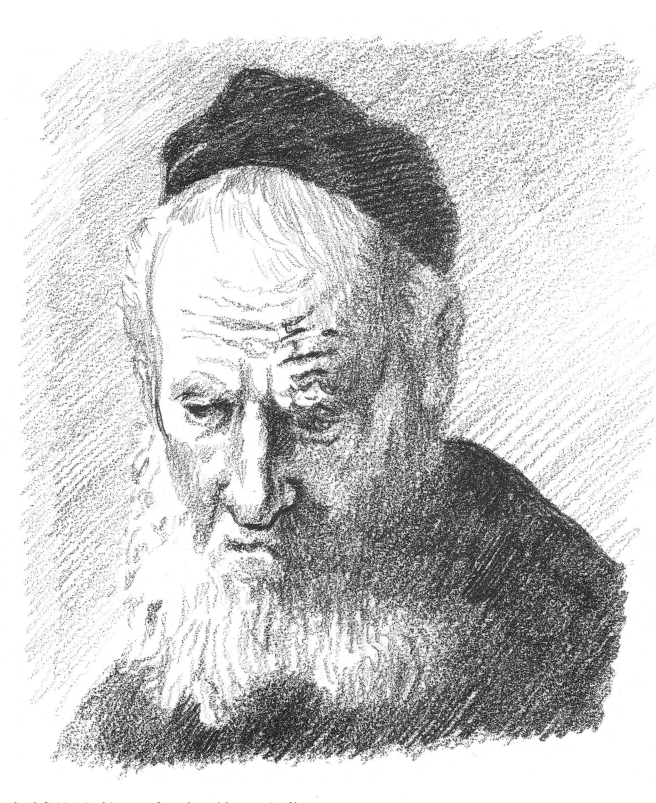

The definition in this copy of **Rembrandt**'s portrait of his
father, who was in his early seventies, derives from the use of
tonal areas instead of lines. The technique with the pencil is
very smudgy and creates an effect that is very similar to one
you would get with chalk.

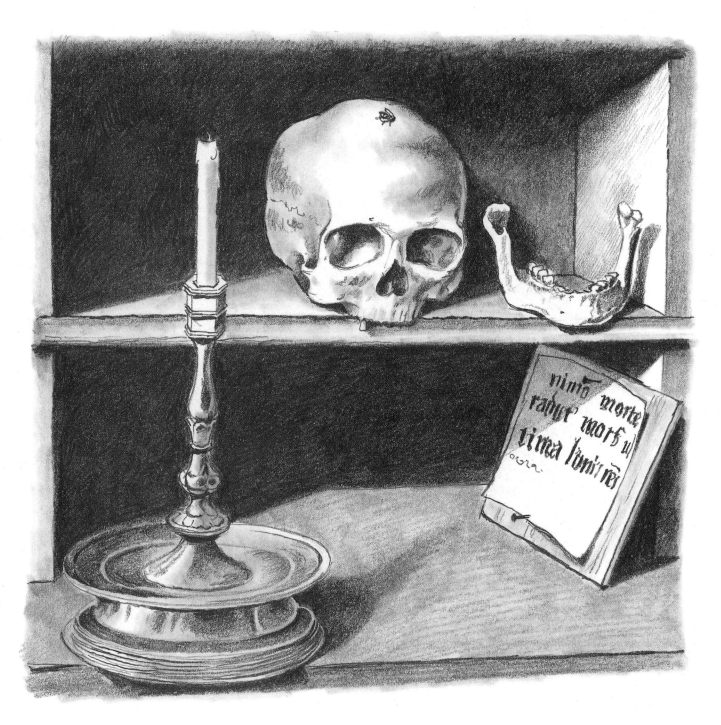

The most obviously symbolic pictures produced in the still-life genre were often concerned with the passing of time and approach of death.

This still life after **Bruyn the Elder (1493–1555)** is a simple but effective composition with its blown-out candle, the skull with its jaw removed to one side and the note of memento mori on the lower shelf. The dark shadows under the shelf set the objects forward and give them more significance.

*In this example of modern symbolism, the figures are very expressive and expressionistic, as many American works were at this time. The reduction in physical solidity emphasizes elegance and vibrancy.*

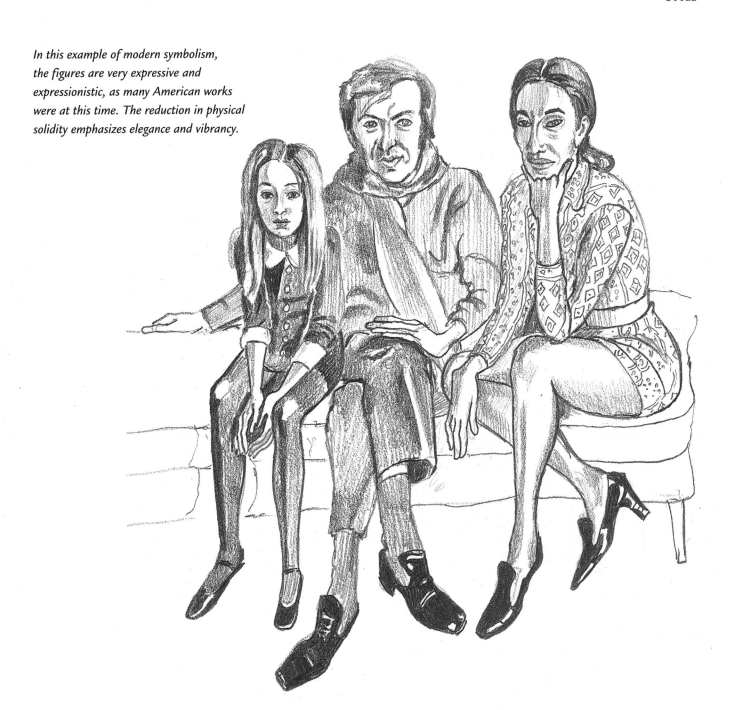

*The Family* by **Alice Neel (1900–1984)** can be read as a genuine exposition of the values of the New York artistic scene in 1970. The girl and the woman share many traits that set them in their milieu: long hair, long-sleeved short-skirted dresses, thin pared-down legs and elongated fingers. These point to a specific view of cutting-edge fashion. Although less obviously trendy, the man is part of the same scene, with his casual scarf, longish hair and long hands with thin fingers. Posed close together, the three of them eye us unflinchingly and not favourably. Their look says, 'We are here, notice us.' Their slightly angular shapes heighten our awareness of their significance as representatives at the cutting edge, more so than their features or what they are actually wearing. One feels that after seeing this picture the sitters would probably grow to be more like Neel's depiction of them.

*This picture is an attempt to convey to the viewer a feeling or idea that is not being expressed in words. Indeed, it may be difficult to express precisely or concisely the effect it has. One picture can be worth a thousand words. It is not easy to get across a concept by visual means, but with a bit of practice it is possible.*

*Try to produce such an image yourself. You can use or adapt the approaches or methods we've been looking at. When you've produced something, show it to your friends and listen to their reactions. If your attempt is suggestive of the idea you wanted to convey, they will quickly be able to confirm it.*

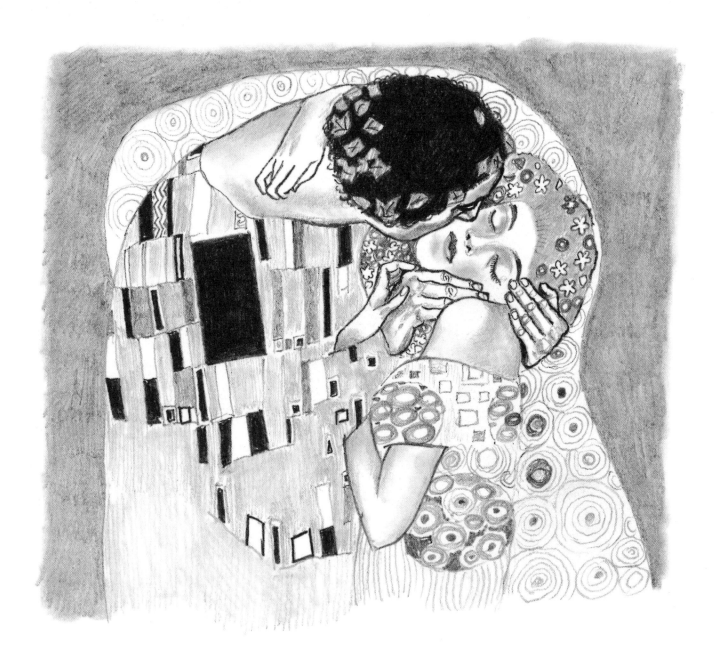

*The Kiss*, by Viennese artist **Gustav Klimt (1862–1918)**, shows the power of desire in a very graphic manner. The heavily ornamented clothing, while revealing very little of the flesh of the lovers, increases the tactile quality of the work. The firm grasp of the man's hands on the girl's face and head, her hands clinging to his neck and wrist, and her ecstatic expression tell us of the force and intensity of their sexual desire.

# Geometry of composition

I n this section, I shall attempt to show how many artists rely not only on their natural ability but also use intellectual devices to produce more powerful works of art. One of the most common ways of achieving a satisfying picture construction is to employ the discipline of geometry, dividing the picture area into various fractions of the whole; taking thirds, quarters and other parts to help construct a balanced composition. Sometimes artists require a more dynamic system that uses sweeping angles and lines of movement through the composition, to draw in the attention of the onlooker. Most artists have some geometrical view of their work, either before they start, or they discover it as they proceed, through simplification. Even the basic decision to have your horizon line high or low in a landscape is a geometrical device in order to create a certain feeling within the final picture. So try this out when composing a drawing. As you will see, I suggest several options that you may find useful.

## Close Groupings

*When dealing with human subjects, all sorts of arrangements can make good compositions, and in the process tell us a great deal about the sitters. It used to be the case that a portrait would include clues as to the sitter's position in society or would show to what he (invariably) owed his good fortune. Most artists, however, are more interested in incorporating subtle hints about the nature of the relationships between the subjects in the groups they portray. You may choose to introduce an object into your arrangement as a device to link your subjects.*

*There are many ways of making a group cohere in the mind and eye of the viewer. In these two examples, both after realist painter* **Lucian Freud,** *the closeness of the arrangements is integral to the final result.*

When composing a picture, consideration of the geometry of the shapes involved is a good way to make a picture that not only holds together as a whole but also creates a dynamic within the composition that gives strength and power to the work.

■ *This arrangement makes a very obvious wedge shape leaning to the right. The shape is quite dynamic, but also very stable at the base. The slight lean gives the composition a more spontaneous feel.*

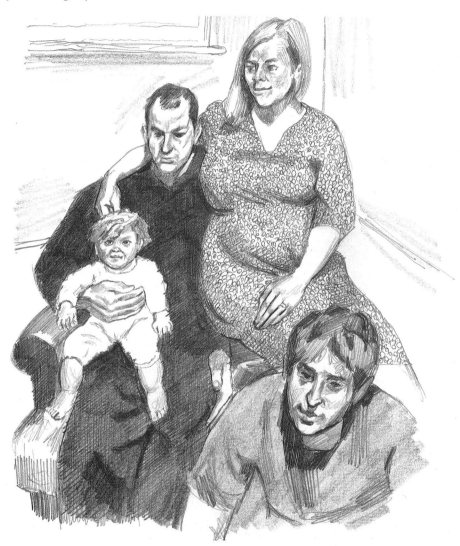

The central interest is shared between the baby and his parents. Our eye travels from the infant to the couple as they support him and each other on the armchair. In front, the elder son is slightly detached but still part of the group. The connection between the parents and the baby is beautifully caught, and the older boy's forward movement, as though he is getting ready to leave the nest, is a perceptive reading of the family dynamic.

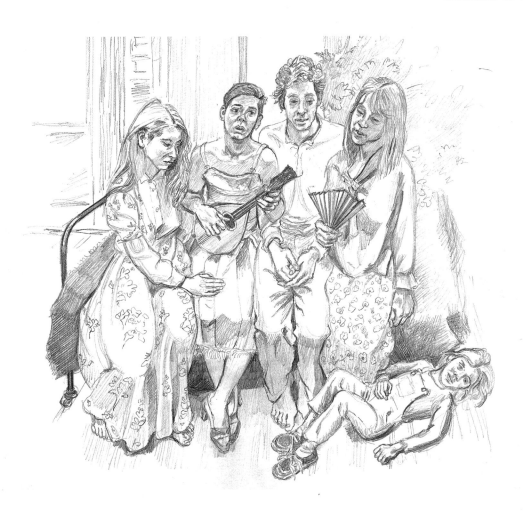

*Large Interior* – after **Watteau** is reminiscent of that artist's *fête champêtre* compositions in which young courtiers are depicted listening to music and enjoying each other's company. Freud transfers the outdoors to a well-lit indoor scene with three young women, a young man, and a child lying at their feet. As in many Watteau paintings the girls are wearing rather flowery, pretty dresses and the boy is garbed in a loose white ensemble, rather like a Pierrot. While the whole ensemble makes for a very friendly grouping, there is an element of a more formal mode of arrangement. In Freud's original the space around the figures produces a very posed, almost artificial effect. Here, even the child lying at the feet of the quartet seems very conscious of her position in the scene.

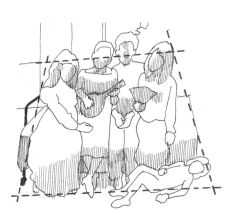

■ *This is a very solid, stable, composed group. The individuals are lined up along the same base with some squashing together of the upper bodies. The reclining figure is almost like an afterthought and contributes to the portrait's spontaneity.*

## Centrepieces

*For a group portrait it is very effective to include a focal point around which the sitters can gather. In bygone times an unwritten rule of portraiture was that the artist should incorporate devices pinpointing the social standing and worthiness of the people* *he painted. Nowadays both artists and sitters are more interested in a presentation that is essentially revealing of character and individuality.*

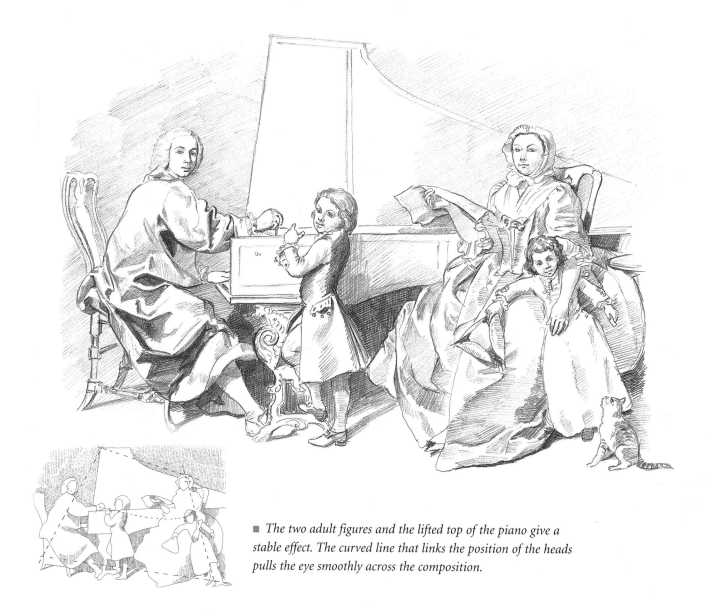

■ *The two adult figures and the lifted top of the piano give a stable effect. The curved line that links the position of the heads pulls the eye smoothly across the composition.*

Like many 18th-century portraits, this one is carefully posed to include clues to the sitters' social position. The artist, **Carl Marcus Tuscher (1705–1751)**, wants to show us that these people are comfortably off – note the care that has gone into the clothing. The head of the family is Burkat Shudi, a well known harpsichord manufacturer and friend of the composer Handel. The piano is centrally positioned but set behind. If we were not sure that the family owes its good fortune to the instrument, Tuscher underlines the connection by posing Shudi at the keyboard with a tuning fork in his right hand, and has the eldest son indicating to the viewer what his father is doing. The arrangement is balanced but relaxed. It is as though we have dropped in on the family unexpectedly at home and found them at leisure.

## Breaking with Convention

*Most of the arrangements we have looked at so far have been formal in terms of their composition and very obviously posed. The approach taken in this next drawing is remarkable. The English painter* **William Hogarth (1697– 1764)** *was notable for his progressive social attitudes, and these are very much to the fore in this powerful and humane piece of work, in which he presents his servants.*

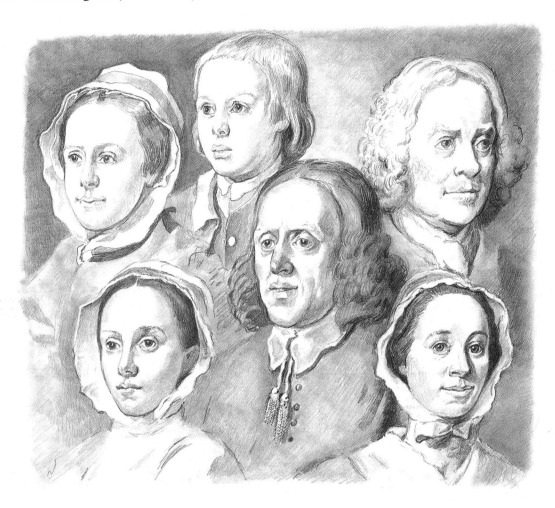

The original Hogarth painting from which this copy was made is an extraordinary essay in characterization. Executed with great brilliance and obvious warmth and sincerity, it shows the artist's servants. The composition is exemplary. Each head, although obviously drawn separately, has been placed in a balanced design in which each face has its own emphasis. Hogarth's interest in his subjects is evident from the lively expressions, and we feel we are getting genuine insights from a man who knew these people well.

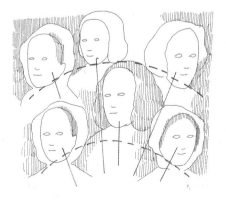

■ *A very straightforward fanning out of the six heads from the base, placed in close proximity. All slightly off-centre but still very symmetrical.*

## Complex Geometry

*Make a practice of studying complex compositions to see where geometric shapes link to hold the figures together. Doing so will help you to think about incorporating such shapes into your own pictures as a matter of course and your compositions will benefit from this method of working.*

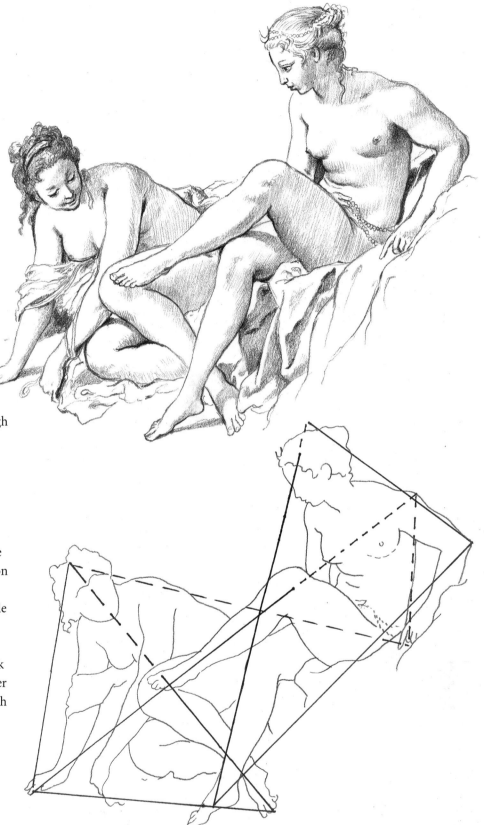

When it is analyzed, this simple enough composition by **François Boucher (1703–1770)** of two goddesses or nymphs at their toilet becomes a complex series of interlinking triangular shapes. The main thrust through the picture goes from the lowest hand on the left up through the knee and leg of the seated figure and on to her upper shoulder. From her head to elbow is an obvious side of a triangle from which two longer sides converge on her lowest foot. The line from the seated figure's upper leg along the back of the kneeling figure produces another possible set of triangles that go through the feet and hand of the lower figure. These interlinking triangles produce a neat, tightly formed composition that still looks totally natural and ideal.

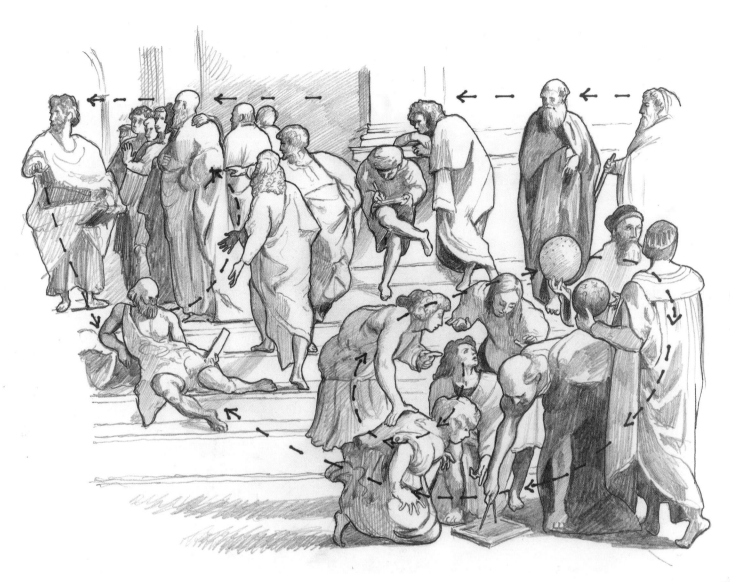

This scene is taken from **Raphael**'s fresco in the Vatican of the *School of Athens*. Here are two loosely related groups of figures set on a staircase that are part of a much bigger composition. In order to make a crowd scene work so that it is not just a random dotting of figures over the setting, Raphael carefully produces closer groups of figures within the large crowd. He helps them to cohere as a composition by using the direction of the individuals' sightlines. For example, note how the uplifted face of the youth in the centre of the group at the bottom right of the picture starts the flow of movement as denoted by the arrowed line. Similarly, one figure by a gesture links one or two figures with another group – see how a double-handed gesture includes the slumped, reclining figure; sometimes figures face in towards each other to produce a centre to a composed set of figures. Raphael also uses the kneeling, sitting and reclining figures to set off the overall standing figures, to stop them becoming too vertically dominant. Raphael was a master of this sort of composition, and it is worth studying sections of large paintings by masters to spot these internal groupings within larger groups and discover how the whole dynamic of the composition works.

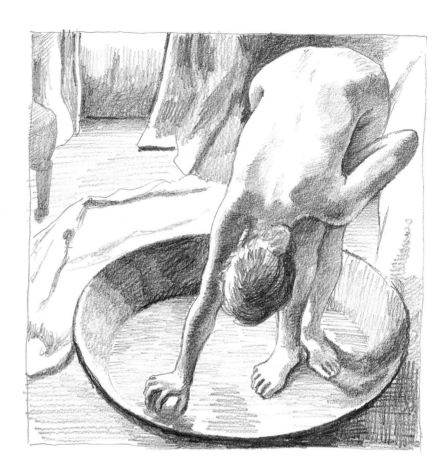

The view taken by **Degas** here is quite extraordinary. We see the upper part of the girl, upside-down as she bends to pick up a sponge. The tub acts as a large, stable base shape and the towel and chair on the floor lead us to the window indicated in the background. Just over half the picture is taken up with this unusual view of quite a simple action and gives an interesting dynamic to the composition. It looks almost as if we have caught sight of this intimate act through an open door. We are close, but somehow detached from the activity, which helps to give the picture a statuesque quality.

Degas has found a very effective way of creating interest just by the arrangement on the canvas. Ordinary, but extraordinary.

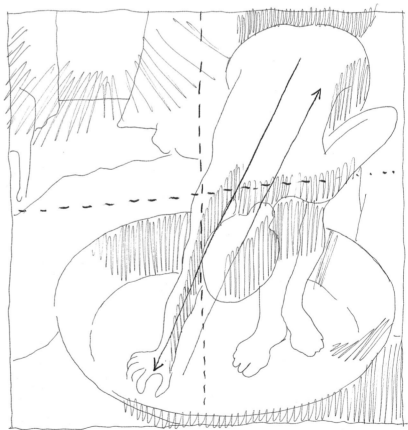

We stay with **Degas**. We are in a 19th-century dance studio, with a master continuing to instruct his pupils as they rest. All the attention is on the master with his stick, which he uses to beat out the rhythm. The perspective takes you towards him. The way the girls are arranged further underlines his importance. The beautiful casual grouping of the frothy dancers, starting with the nearest and swinging around the edge of the room to the other side, neatly frames the master's figure. He holds the stage.

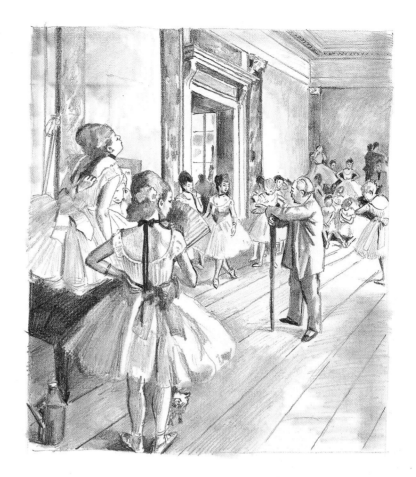

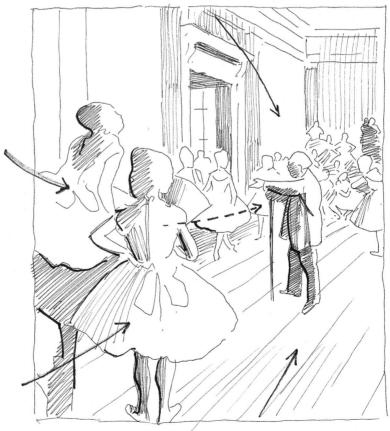

*The pictures shown here are classic examples of the use of geometry. Both Piero della Francesca (c. 1410–1492) were great mathematicians and their handling of geometry in their works reflects this facility.*

*If you want to test the effect of the systems they used, go and look at the originals of these drawings (you'll find the Leonardo in the Uffizi in Florence and the della Francesca in the National Gallery, London).*

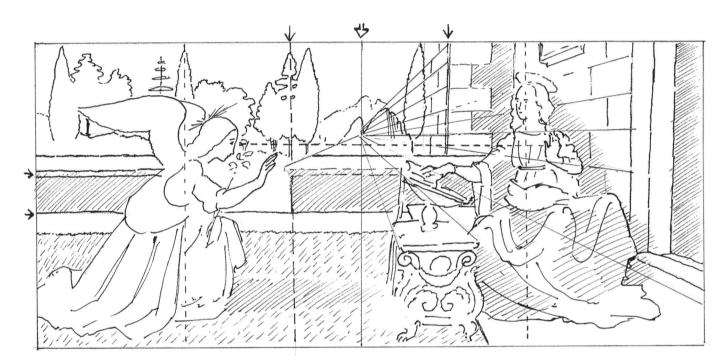

The *Annunciation* by Leonardo is centred on a 'cleft' (the mountain in the background) to which point all the perspective lines converge. (This symbol of the cleft earth is often used in paintings in conjunction with God's incarnation in human form.) The picture is divided vertically into two halves by this point and horizontally by a long, low wall dividing the foreground garden from the background landscape. The angel's head is about central to the left half of the picture and the Virgin's head is about central with the right half of the picture.

The scene seems to be divided vertically into eight units or areas of space: the angel takes up three of these spaces, as does Mary, and two units separate them.

The angel's gaze is directed horizontally straight at the open palm of Mary's left hand, about one third horizontally down from the top edge of the picture.

All the area on the right behind Mary is man-made. All except the wall behind the angel is open landscape or the natural world.

In Piero della Francesca's *Baptism of Christ* the figure of Christ is placed centrally and his head comes just above the centre point of the picture. The figure is divided into thirds vertically by a tree trunk and the figure of St John the Baptist. The horizon hovers along the halfway line in the background. The dove of the Holy Spirit is about one third of the way down the picture, centrally over Christ. His navel is about one-third above the base of the picture. The shape of the bird echoes the shape of the clouds and because of this doesn't leap out at us. The angels looking on in the left foreground, and the people getting ready to be baptized in the right middle ground, act as a dynamic balance for each other.

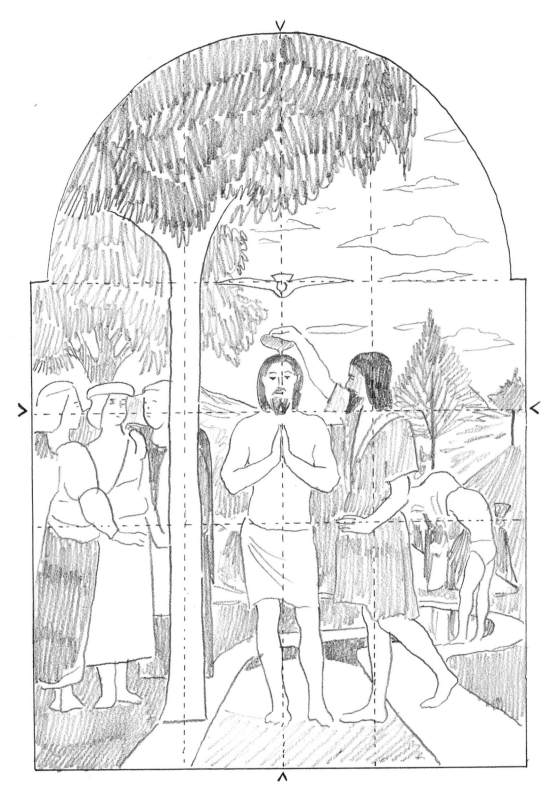

## Geometric connections

*The structural strength of your composition will depend on you making geometric connections between the various features you decide to include. These connections are vital if your picture is to make a satisfying whole. Look at*

*any picture by a leading artist and you will find your eye being drawn to certain areas or being encouraged to survey the various parts in a particular order. Here are some examples where the connections have been made for you.*

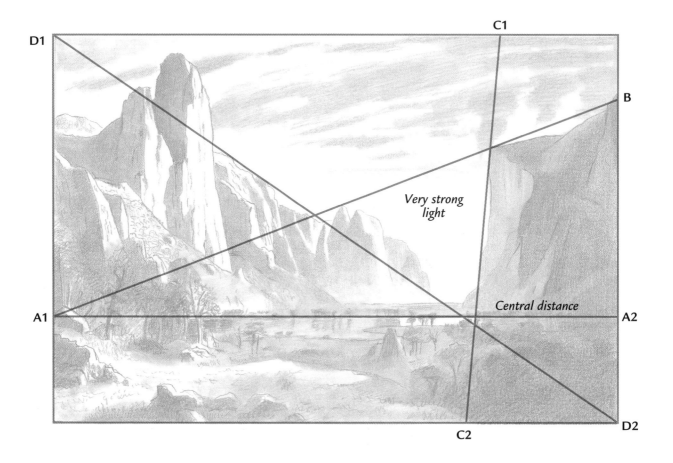

A very interesting geometric analysis can be made of this drawing of a valley in what is now Yellowstone National Park (after American wilderness painter **Albert Bierstadt**).

- A1–A2 follows the line of a stretch of water running through the valley and makes a very strong horizontal across the composition. Note that it is slightly below the natural horizon.
- D1–D2 traverses the composition

diagonally from the top left corner to bottom right, cutting across the horizontal A where the sunlight shines brightly in reflection on the water. The line also gives a rough indication of the general slope of rocky cliffs on the left as they recede into the distant gap in the mountains.

- A1–B makes a sort of depressed diagonal from the top of the mountain on the right side.

- The near vertical C1–C2 describes the almost perpendicular cliff on the right side.
- The very brightest part of the picture, where the sun glows from behind the cliff (right), resides in the triangle described by the lines A1–B, the diagonal D1–D2 and the vertical C1–C2.

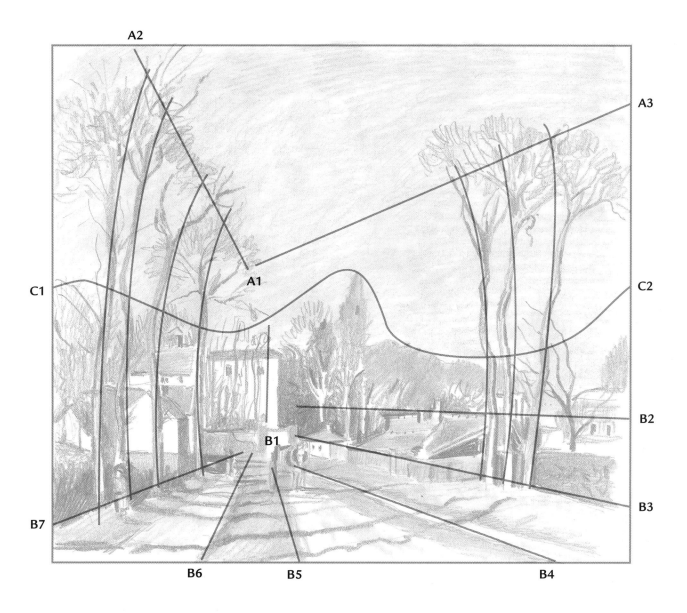

**Pissarro**'s composition of a lane seen along an avenue of slender trees gives an almost classic perspective view, where the main lines subtly emphasize movement into the distance.

The lines A1 radiating to A2 and A3 give the heights of the avenue of trees.

Lines B1 to B7 similarly indicate the lower ends of the trees and the edges of the path and roadway. Everything radiates out or converges inwards to B1. At this point in the picture observe the strong line at the edge of the building behind the horse and cart. Note too how the two rows of trees are linked by means of the curving shadows thrown across the roadway. The wavy horizon line C1–C2 denotes the various heights of trees in the distance.

# Simplifying composition

Here, I aim to demonstrate how you might approach your composition in a simplified way in order to get the most out of it. Reducing a picture to its basic shapes does encourage a more powerful result, and many works that particularly command your attention in art galleries do so as a result of such understanding by the artists who produced them. This section samples many masterpieces, revealed in their most simple outlines, in order to examine how they work on the viewer. You can try this for yourself when in a gallery, or when looking at art books, by reducing the compositions in your mind's eye to the very simplest surface areas. You will quickly get the hang of the exercise and it also serves to enhance your appreciation of the work of that particular artist. Then, of course, try it with regard to your own work, especially before you reach the final stages, and it could well have the effect of producing a more satisfactory piece of work.

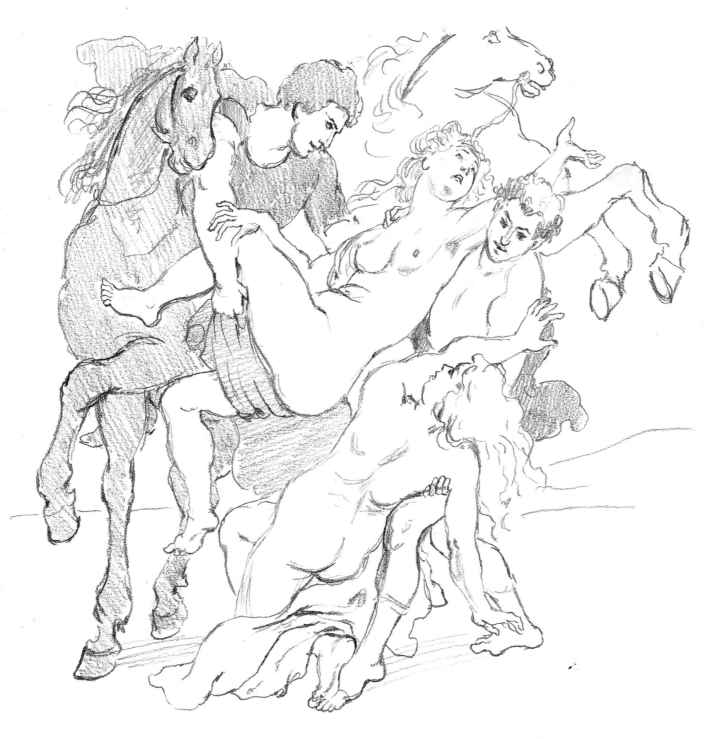

In this copy of **Peter Paul Rubens's (1577–1640)** painting of the rape of the daughters of Leucippus, the fidgeting of the horses gives context to the human action and lends amazing dynamism to the scene.

In the foreground we see two nubile young women being lifted up onto the horses in front of the powerful male riders. Although there are only two horses and four figures, the baroque movement of these beings creates a

powerful dramatic action. This is a complex composition, and sketching the different elements will help you to break it down and make sense of it.

## Analysis

*Compositionally,* **Pierre Auguste Renoir's (1841–1919)** Boating Party *is a masterly grouping of figures in a small space. The scene looks so natural that the eye is almost deceived into believing that the way the figures are grouped is accidental. In fact, it is a very tightly organized piece of work. Notice how the groups are linked within the carefully defined setting – by the awning, the table of food, the balcony – and how one figure in each group links with another, through proximity, gesture or attitude.*

*Let's look at the various groups in detail.*

**▓ Group A:** In the left foreground is a man standing, leaning against the balcony rail. Sitting by him is a girl talking to her dog and in front of her is a table of bottles, plates, fruit and glasses. It is obviously the end of lunch and people are just sitting around, talking.

**▓ Group B:** In the right foreground is a trio of a girl, a man sitting and a man standing who is leaning over the girl, engaging her in conversation.

**▓ Group C:** Just behind these two groupings are a girl, leaning on the balcony, and a man and woman, both seated.

**▓ Group D:** Behind this trio, two men are talking earnestly, and to the right of them can be seen the heads and shoulders of two men and a young woman in conversation.

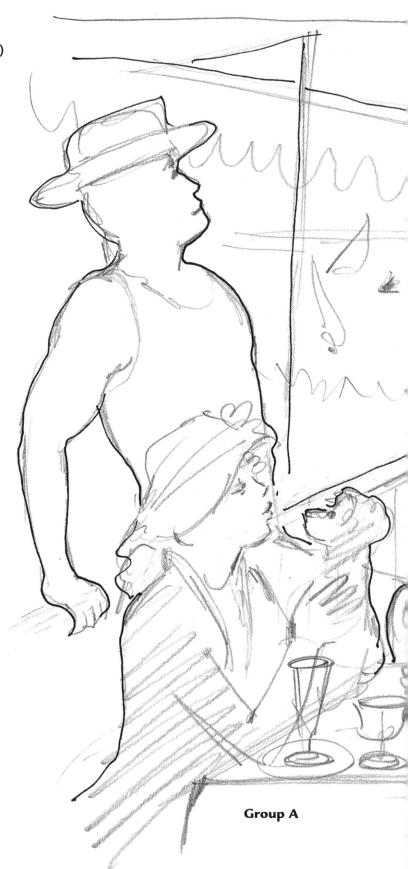

**Group A**

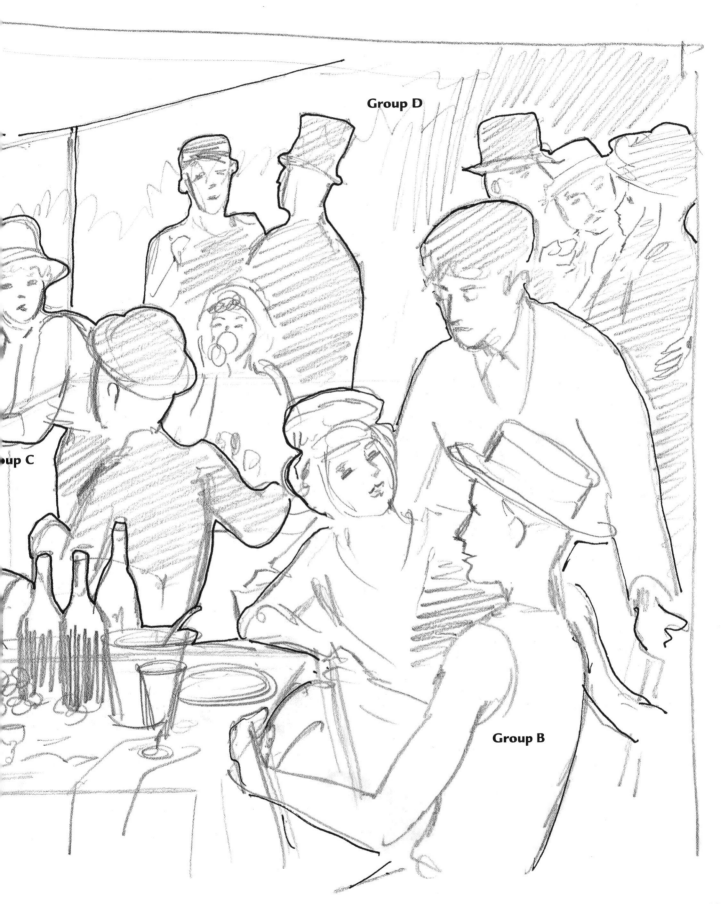

In **Georges Seurat**'s large, open-air painting *The Bathers*, the composition is effectively divided in two: the horizon line with factories along it comes about two-thirds above the base of the picture, and the diagonal of the bank runs almost from the top left of the picture down almost to the bottom right corner. The larger figures are grouped below this diagonal. The picture is drawn as though the viewer is sharing the quiet calm of the day with them, surveying the people sitting on the grass and in the boat on the river and the scene beyond. This is probably one of the most carefully thought-out pieces of picture-making of any painting made after the Impressionists. It is painted in Seurat's customary fashion from many preliminary drawings and colour sketches of all the figures and parts of the background. He would carefully orchestrate each part of his picture in the studio, painting systematically from his studies and placing each one so that the maximum feeling of balance and space was made evident in the finished picture. This is a brilliant piece of composition by any standards with its diagonal bank of the river, the horizon about two-thirds up, the still figures placed in the foreground and the expanse of water with trees either side holding the centre space.

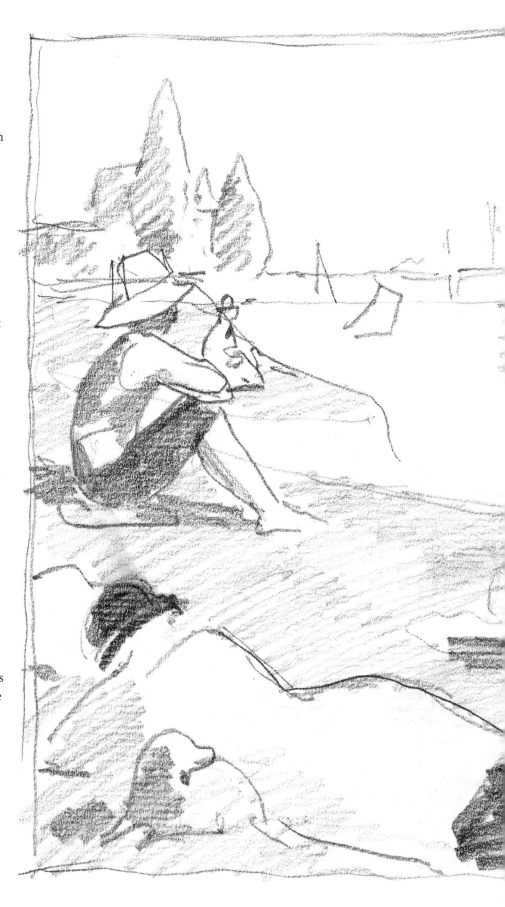

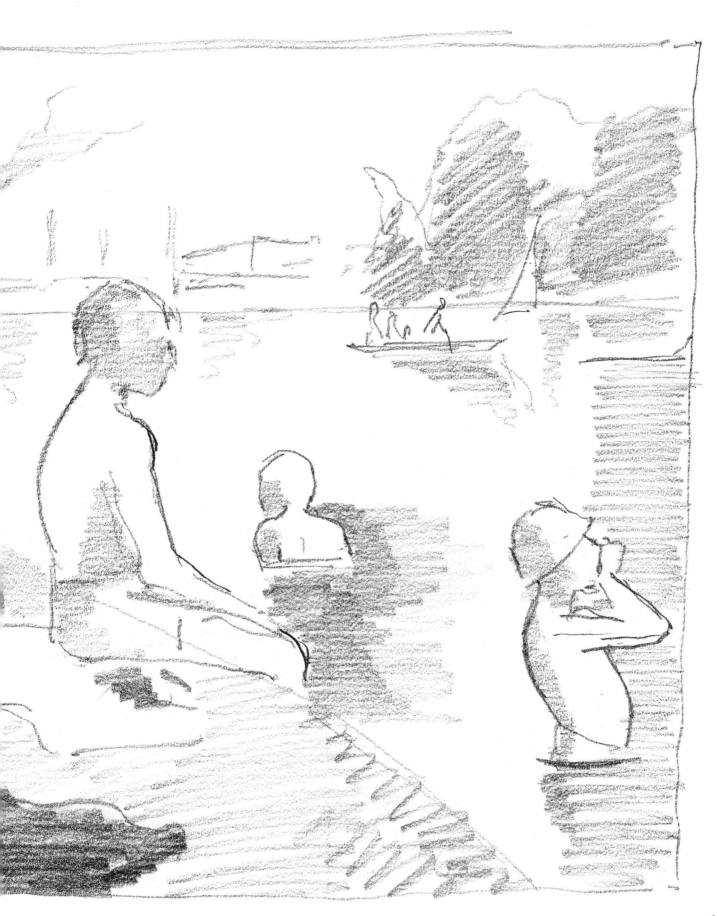

## Abstract and naturalistic design in composition

Some pictures, while appearing to be purely abstract in conception, are in fact naturalistic and portray actual things. *Street in Delft* by **Johannes Vermeer (1632–1675)** is a remarkable picture for its time. Cut diagonally in half from bottom left to top right, the lower half is filled with the façade of a building and most of the upper half is taken up with sky. The house is built out of a series of rectangles for the windows and door, enhancing the picture's geometric effect, even though other details suggest a real house with real inhabitants.

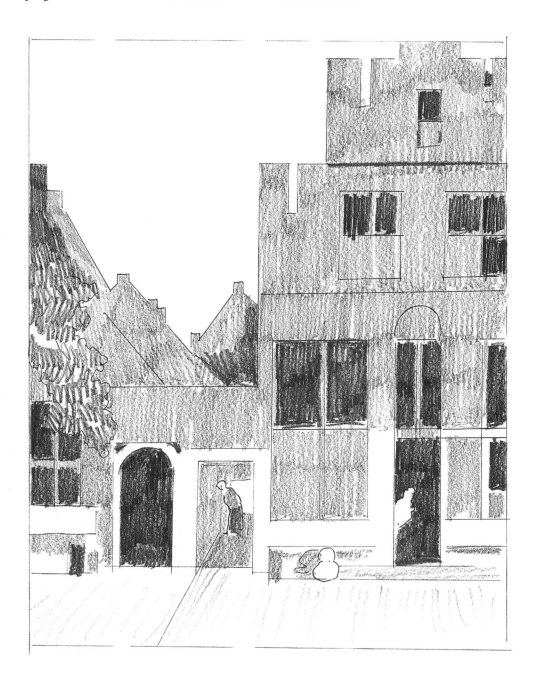

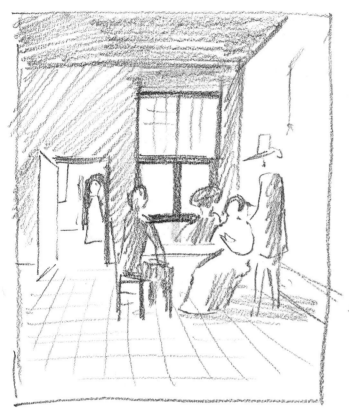

This copy of a **Pieter de Hooch** is less intimate than the von Menzel below by virtue of the fact that the viewer is kept at some distance from the group sitting in the room. The area above them is dark except for the light coming in through the window at the back. The doorway to the left allows us to see even further into the picture. If you ask a child or an adult unpractised in art to draw a scene, they tend to set the action in distant space, as here.

The advent of the camera and the influence of techniques evident in the work of Japanese printmakers encouraged Western artists to cut off large areas of foreground so as to increase dramatic effect and bring the viewer into the scene. This interior by **Adolphe von Menzel (1815–1905)**, *Living Room with the Artist's Sister*, is like a cinema still: the viewer is standing the other side of the lit open doorway, looking into the room where someone sits in front of a light. We are confronted by two contrasting images – of an inner world from which we are cut off by the door and the anonymity of that lone figure in the background, and of the girl who is looking expectantly out towards us. We wonder what this girl is waiting for and we wonder about her relationship with that other figure.

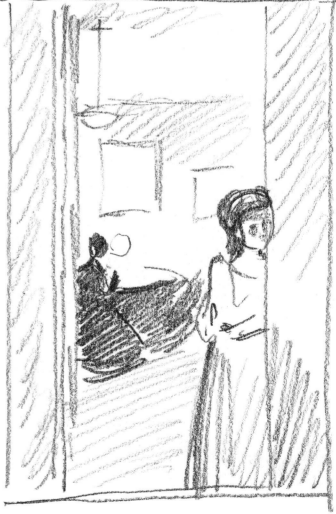

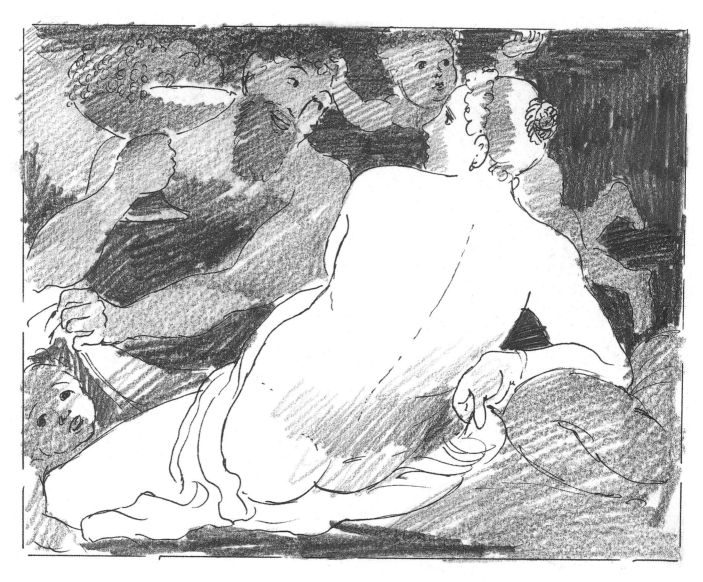

In these two sketches of **Paolo Veronese**'s (1528–1588) *Venus with Satyrs and Cupid*, a very simple compositional device has been used for added sensuality. The bare back of Venus is revealed to us as she stretches across the picture plane, sharply lit against the dark, chaotic space in front of her where the moving shapes of the satyrs and Cupid can just be made out.

The great **Leonardo da Vinci** pioneered several different approaches to figure composition which influenced all the artists of his generation and many years after. This strange composition of Mary sitting in the lap of her mother (St Anne) and leaning over to pick up the infant Jesus as he plays with a lamb creates a large triangular shape rather like the mountains in the background. The composition has great stability even though there is swooping movement curving across it and the two movements contrasting with each other create a very interesting design.

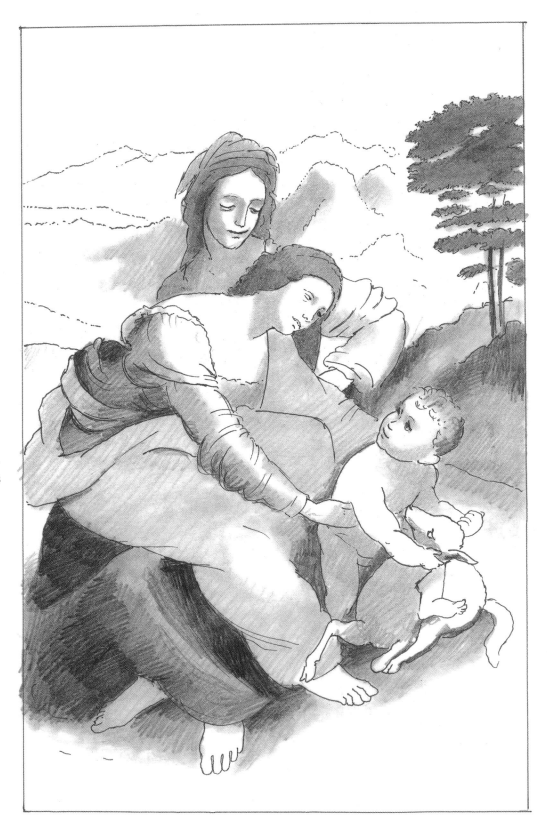

## The sky: expressive clouds

*The sky plays a very dramatic role in the following example of a landscape, a copy of* **Vincent Van Gogh's (1853–1890)** *picture of a cornfield with cypress trees. Although it looks complex, this type of landscape is in fact easier to do than it looks.*

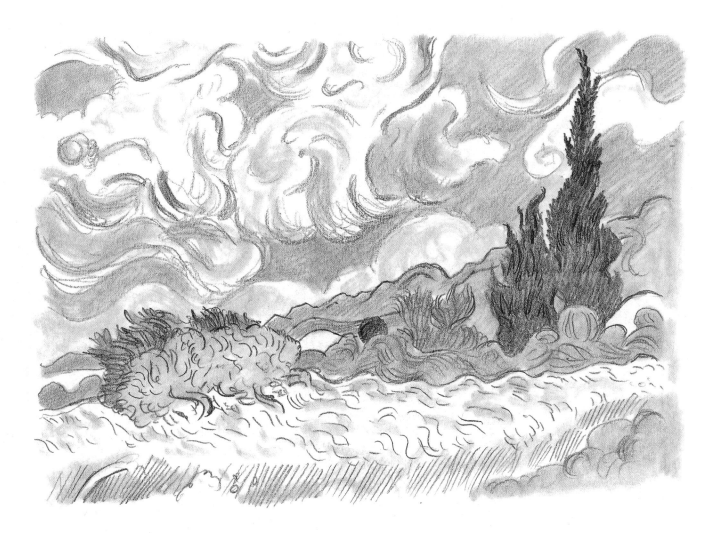

The **Van Gogh** copy is characterized by strange, swirling mark-making for the sky, trees and fields. The feeling of movement in the air is potently expressed by the cloud shapes which, like the plants, are reminiscent of tongues of fire. Somehow the shared swirling characteristic seems to harmonize the elements. The original painting was produced while the artist was a patient in the St-Remy mental asylum, near Arles.

# Analysis of ingredients

This is a similar exercise to that of the previous section, but this time we examine the actual content of a picture in order to produce something more significant ourselves. Many artists have created works of art in which small details encode meanings that increase the effectiveness of the overall picture; sometimes they are purely symbolic. But often they are more of a design feature, which lends authority to the subject matter of the whole composition.

Everything in a picture makes some contribution to the final result, and can be to your advantage or disadvantage.

It is the mark of a good professional that nothing is really left to chance, even if a certain element looks as though it was an accidental touch rather than included on purpose. So here we analyze a selection of the details of great works, in order to understand how they can help us with our own, especially when we are contemplating a major piece of drawing. It is great fun to do all this, and even if at first it doesn't seem to work in your case, keep looking and analysing because eventually you will discover ways of using your observations.

## Portraits: active and passive partners

*Even the most unlikely pieces of furniture or most mundane objects can be used to create interest in a portrait. Props to produce a setting for a portrait are usually made to look as natural as possible in order to convince the viewer that this is how the artist found the subject when drawn. If they do their work well the result looks natural but provides information to help us connect with the subject. Of course, sometimes props are just incidental and act merely as aesthetic devices to round off the shape or colour of the portrait, but nevertheless do their job.*

*A useful rule is not to include anything that takes too much attention from the face. Having a prop as a focal point can be a good idea, but it should never be allowed to upstage the main participant. In these examples we find props playing a variety of roles to varying degrees, either as indications of narrative or as symbolic devices.*

This copy of a portrait of a Flemish banker (1530) **by Jan Gossaert (c. 1462–c. 1533)** shows him at his desk writing. Around him are quill pens, inkwell, penknife, paper and so on – all that he needs for writing bank drafts, account loans and bills, some of which are suspended on the wall behind him, tied up in bunches (right).

## Symbols of power

*Symbolism has always been used as a vehicle for reinforcing the images of the powerful. Absolute monarchy became a hot topic in the 17th century, especially in England where it cost a king (Charles I) his head. Here we see two very different depictions of kingship, each reflecting political reality.*

■ *The double column of Roman design suggests stability and power.*

■ *The jewelled sword from a different age suggests continuity of the monarchy.*

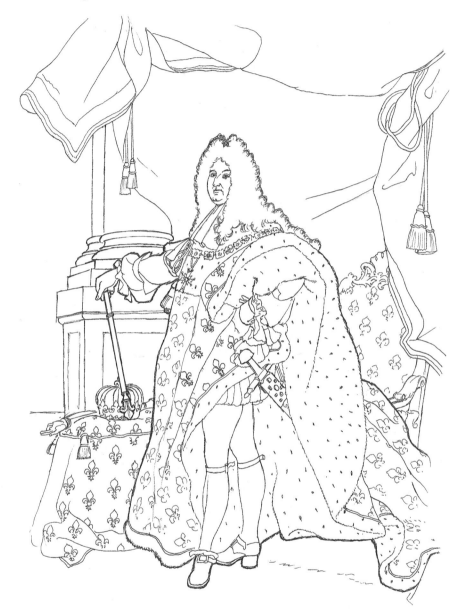

**Hyacinth Rigaud (1659–1743)** depicts the Sun King, Louis XIV, as the personification of absolute monarchy. The haughty pose, flamboyant but with a distancing quality, declares the monarch's position of supremacy within the state. The showing of the king's legs was traditional in full-length portraits of monarchy in this period, and the hand on hip depicts aristocratic concern. The drapes hanging above and to his right allude, rather theatrically, to the monarchy's central role in the politics of France and Europe. The extraordinary gesture of holding the sceptre upside down, like a walking stick, shows that the king is above showing the respect that is normally paid to such an important badge of office. The ermine-lined robe trailing across the dais covered in fleur-de-lys – the emblem of French monarchy – further emphasizes his unequalled status. Every gesture, object and material in this portrait is a symbol of the regal power of the king of France. Finally, he is shown wearing a periwig of the latest design, implying that the French king creates the fashion that lesser monarchs copy later.

## Creating a composition

*Most artists draw or paint the elements in their compositions piecemeal and then fit them together in the studio. Here I have deconstructed an* **Edouard Manet (1832–1883)** *by separating out the individual parts of his picture and then reassembling them as he did. Try this system yourself – you should not find it too difficult to do it effectively. Manet arranged the elements shown here to produce a rather intriguing picture. Let's discover why it works so well compositionally.*

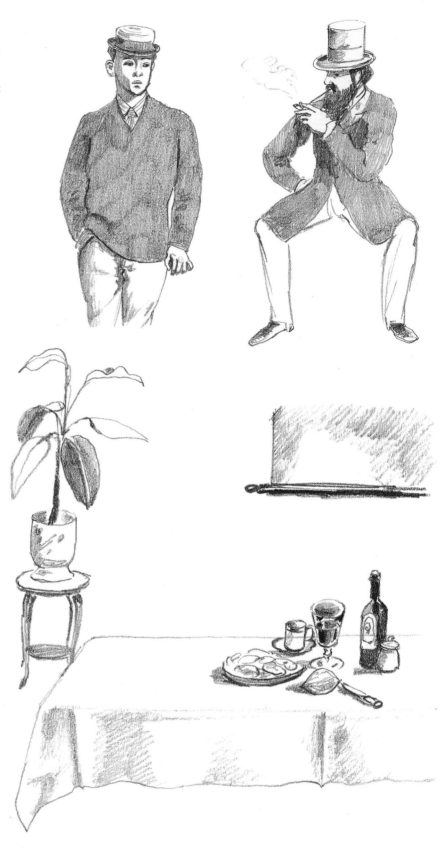

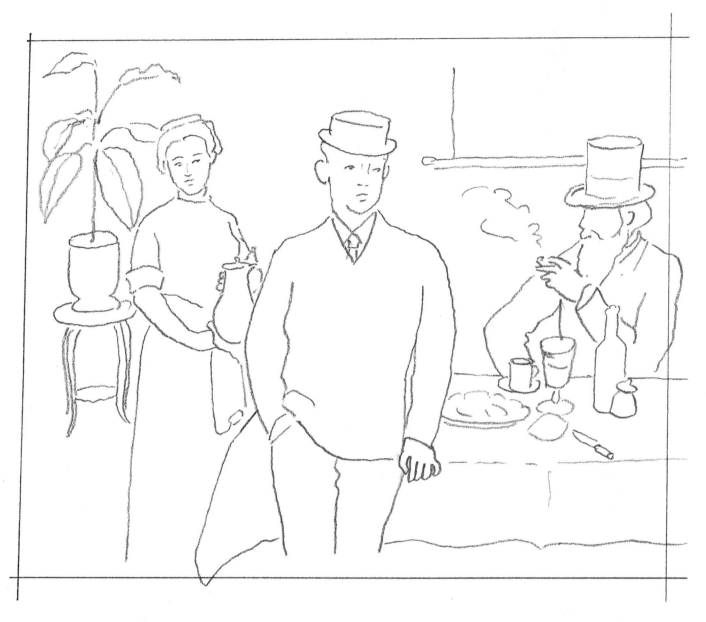

A cursory glance tells us that we are witnessing the end of a meal enjoyed by two men, whether alone or separately we are not sure. Neither is communicating with the other. The woman with the jug has been placed in the background with the potted plant to the left of her, thus acting as a frame and serving to make her part of the narrative. The older man looks in the direction of the woman, the woman looks questioningly at the younger man and he looks beyond, out of the picture.

When you create a composition have in mind the poses you want to put together, then draw them separately. Afterwards draw in the background, including still-life objects, to make the scene convincing. If you decide that you want an outdoor setting, draw the background first and then decide how you will fit the figures in before you draw them separately. Some artists look for backgrounds to suit the figures they want to draw. The important point is to match the shapes and sizes carefully so that the proportions work.

## The middle ground

*If a foreground has done its job well, it will lead your eye into a picture, and then you will almost certainly find yourself scanning the middle ground. This is, I suppose, the heart or main part of most landscape compositions and in many cases will take up the largest area or command the eye by virtue of its mass or central position. It is likely to include the features from which the artist took his inspiration, and which encouraged him to draw that particular view. Sometimes it is full of interesting details that will keep your eyes busy discovering new parts of the composition. Often the colour in a painting is strongest in harmony and intensity in this area. The story of the picture is usually to be found here, too, but not always.*

*The eye is irresistibly drawn to the centre and will invariably return there no matter how many times it travels to the foreground or on to the background. The only occasion when the middle ground can lose some of its impact is if the artist decides to reduce it to very minor proportions in order to show off a sky. If the proportion of the sky is not emphasized the eye will quite naturally return to the middle ground.*

*Let us now compare two sharply contrasting treatments of the middle ground in paintings. In order to emphasize the area of the middle ground, I have shaded the foreground with vertical lines and the extent of the background is indicated by dotted lines.*

The centre of this picture (after **John Knox, 1778–1845**) contains all the points of interest. We see a beautiful valley of trees and parkland, with a few buildings that help to lead our eyes towards the river estuary.

There, bang in the centre, is a tiny funnelled steamship, the first to ply back and forth along Scotland's River Clyde, its plume of smoke showing clearly against the bright water. Either side of it on the water, and making a nice contrast, are tall sailing ships. Although the middle ground accounts for less than half the area taken up by the picture, its interesting layout and activity take our attention.

No attempt has been made here (after **Constable**'s picture of his uncle's house at East Bergholt) to centralize or classicize the arrangement of buildings. Constable believed in sticking to the actuality of the view rather than recomposing it according to time-honoured methods. The result is a very direct way of using the middle ground, a sort of new classicism. Our eye is led in to the picture by the device of the diagonal length of new wall dividing the simple dark foreground from the middle ground. The sky and a few treetops are all there is of the background; note how some of the sky is obscured by trees in the middle ground. Everything ensures that the attention is firmly anchored on the middle ground, where the main interest of the buildings is emphasized by the small space of the garden in the front. The composition is more accidental-looking – and therefore more daring – than was generally the case at that time.

117

## Significant skies

*These next examples bring into the equation the basic background of most landscapes, which is, of course, the sky. As with the sea in a landscape, the sky can take up all or much of a scene or very little. Remember, you control the viewpoint. The choice is always yours as to whether you want more or less sky, a more enclosed or a more open view.*

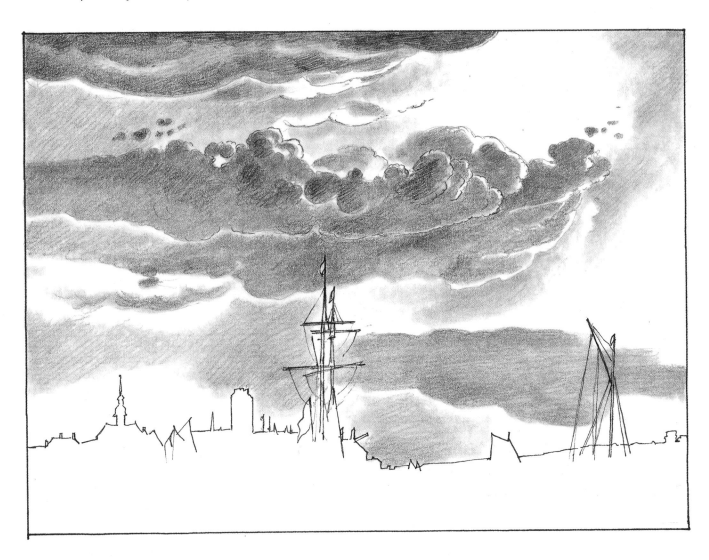

Our first example (after **Aelbert Cuyp (1620–1691)**) is of a dramatic sky with a chiaroscuro of tones. Very low down on the horizon we can see the tops of houses, ships and some land. The land accounts for about one-fifth of the total area, and the sky about four-fifths. The sky is the really important effect for the artist. The land tucked away at the bottom of the picture just gives us an excuse for admiring the vast spaciousness of the heavens.

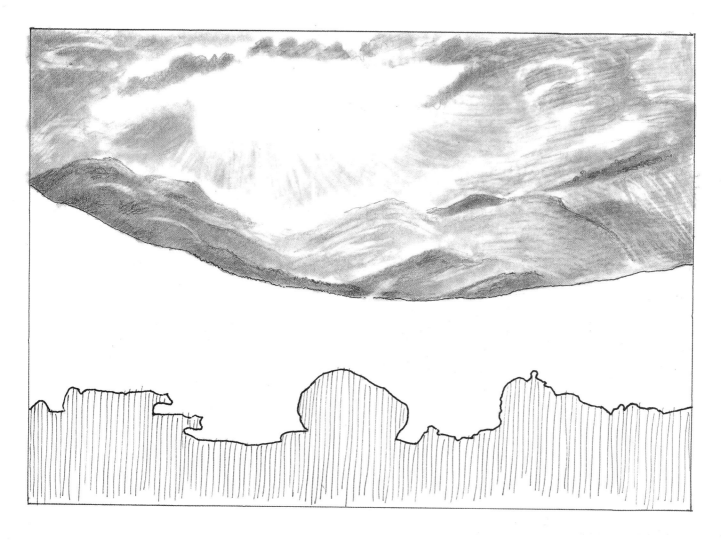

Simmer Lake (after **J.M.W. Turner**) is a good example of that great artist's interest in the elemental parts of nature. The background of sky and mountains does not have the restlessness we associate with much of his work but is nevertheless fairly dramatic. The great burst of sunlight coming through swirling clouds and partly obscuring the mountains gives a foretaste of the scenes Turner would become renowned for, where the elements of sunlight, clouds, rain and storms vie for mastery in the picture.

# Now draw this…

This is the last section, and is in fact an extended drawing exercise designed to test your progress. All the given examples are deliberately chosen to be difficult, and just trying to copy them will serve to improve your own technique. Don't worry if your initial attempts are a little unresolved because, as I must point out, these are great master drawings. The main thing is to make the attempt and, if you have any success at all, you may compliment yourself on an excellent piece of practice. When you have done these, there is another little exercise that you might want to try as well. Get a large print or photocopy of a drawing that really impresses you and make a careful tracing of the main shapes in the composition. Re-trace those outlines onto some good-quality drawing paper and then, with the print set up in front of you, try to copy it as exactly as you can. This will give you considerable insight into the expertise of the original artist and will be a great exercise for refinement of your own style. Work on it for as long as you think is necessary, until you have achieved a satisfactory version of the original. As a drawing exercise, it can be very revealing.

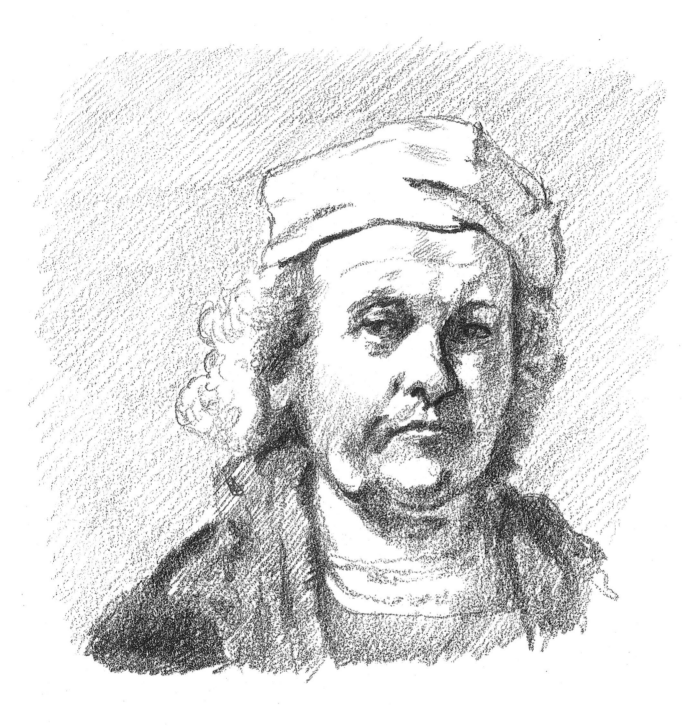

**Rembrandt** drew himself repeatedly throughout his life, from early adulthood until just before his death, and has left us an amazing record of his ageing countenance. In this copy of a self-portrait done when he was about sixty years old, a smudgy technique with a soft 2B pencil was used in imitation of the chalk in the original.

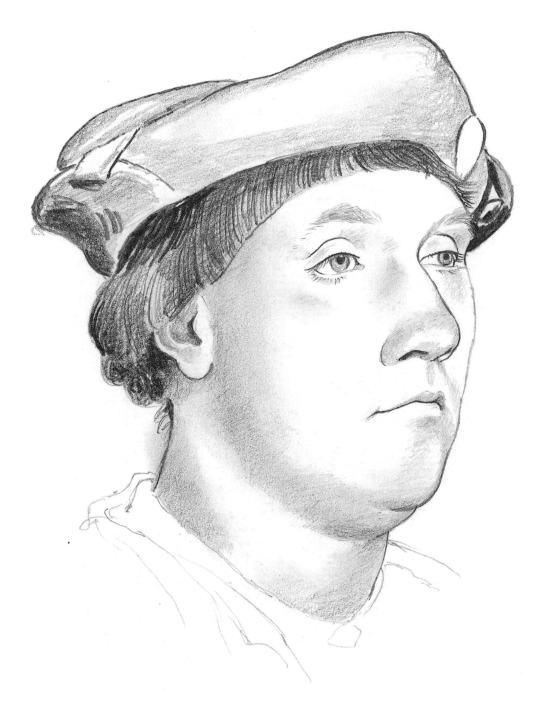

**Hans Holbein the Younger (1497/8–1543)** left behind some extraordinarily subtle portrait drawings of various courtiers whom he painted during his time as court painter to Henry VIII. These works are now in the Queen's Collection (most of them at Windsor, but some are in the Queen's Gallery at Buckingham Palace), and are worth studying for their brilliant subtle modelling. These subjects have no wrinkles to hang their character on, and their portraits are like those of children, with very little to show other than the shape of the head, the eyes, nostrils, mouth and hair. Holbein has achieved this quality by drastically reducing the modelling of the form and putting in just enough information to make the eye accept his untouched areas as the surfaces of the face. We tend to see what we expect to see. A good artist uses this to his advantage. So, less is more.

**Paul Gauguin (1848–1903)** gave the original of this chalk copy (1888) to Van Gogh as a gift. He called it Les Miserables, a reference not only to the traditional poverty of artists but also to their bondage to the quest for perfection.

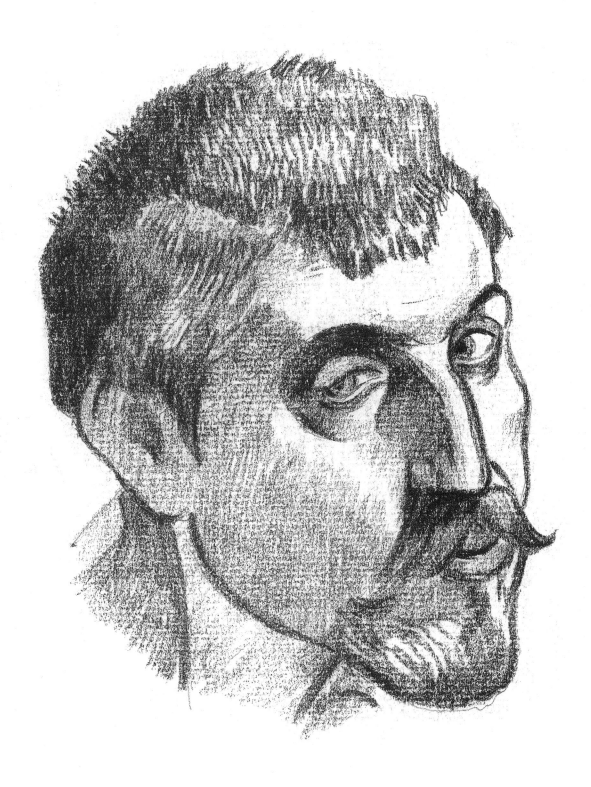

For an example of a three-figure composition I have drawn *The Three Graces* by **Peter Paul Rubens**, the great master painter of Flanders. He chose as his models three well-built Flemish girls, posed in the traditional dance of the graces, hands intertwined. Their formation creates a definite depth of space, with a rhythm across the picture helped by the flimsy piece of drapery used as a connecting device. The flow of their arms as they embrace one another also acts as a lateral movement, so although these are three upright figures, the linkage is very evident. The spaces between the women seem well articulated, partly due to their sturdy limbs.

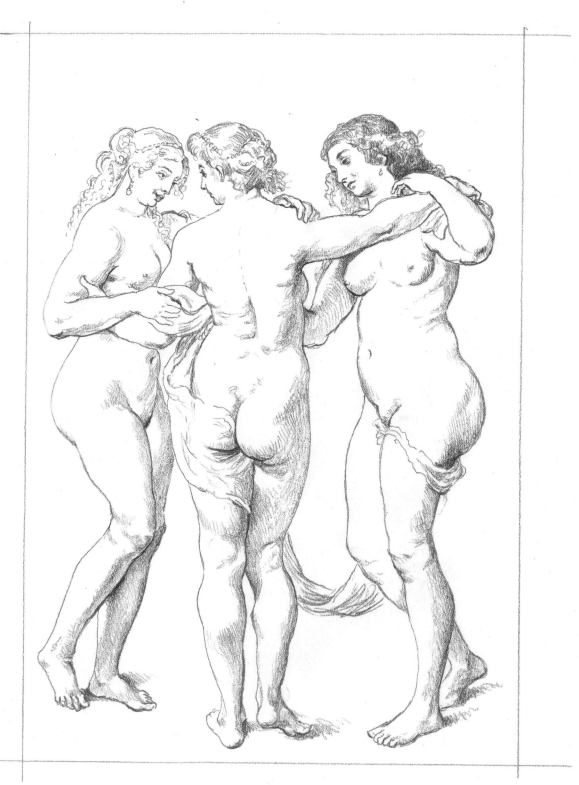

The graphic painting style of **Henri de Toulouse-Lautrec (1864–1901)** gives a clear understanding of the creases and folds in the girl's thin cotton petticoat, drawn with the minimum of modelling but expressing very clearly the solidity of the body under the garment. Mireille, a prostitute from the Salon in the Rue des Moulins, was a favourite model of Lautrec. Here she lounges in the Salon waiting for customers, casually holding one sturdy black-stockinged leg while stretching out the other.

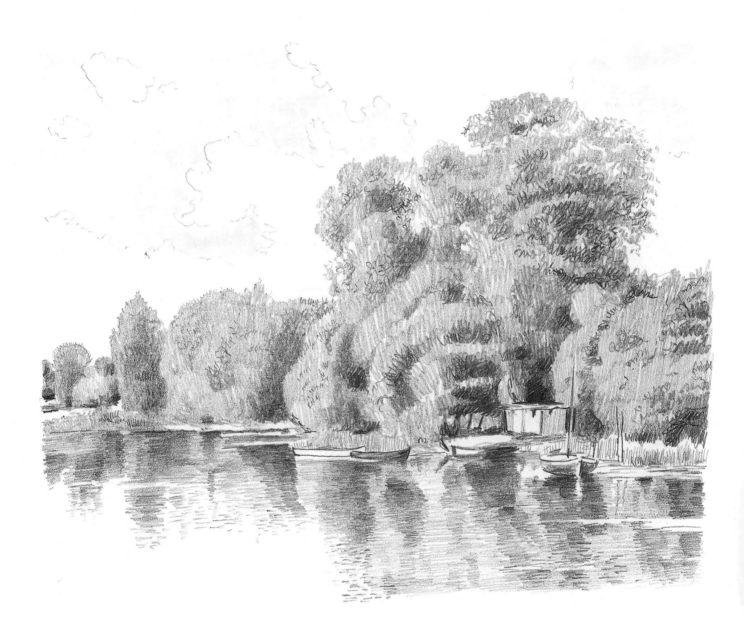

The River Oise in summer looks inviting in this depiction by **Emilio Sanchez Perrier (1855–1907)**. The leafy trees are presented as a solid mass, bulking up above the ripples of the river, where the shadowed areas of the trees are strongly reflected. The many horizontal strokes used to draw these reflections help to define the rippling surface of the calmly flowing river.

The rich bunches of dahlias in this picture after **Henri Fantin-Latour (1836–1904)** have an almost tactile quality to the creamy plush blossoms. They are lit with a soft light against a shadowy background that helps to produce a strong impression of depth and texture. Fantin-Latour's flower paintings are some of the most admired in the genre.

# Index